AMERICAN BLESSINGS

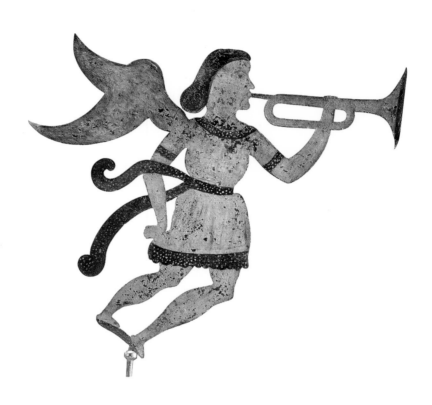

AMERICAN BLESSINGS

A Celebration of Our Country's Spirit

COURAGE
BOOKS

AN IMPRINT OF RUNNING PRESS
PHILADELPHIA · LONDON

9 8 7 6 5 4 3 2 1

Digit on the right indicates the number of this printing

Library of Congress Cataloguing-in-Publication Number 2002100688

ISBN 0-7624-1387-5

Designed by Matthew Goodman
Edited by Michael Washburn
Art researched by Susan Oyama

All cover images courtesy of Abby Aldrich Rockefeller Folk Art Museum, Williamsburg, VA
Front cover: Statue of Liberty Weathervane, artist unidentified, c. 1886-1910
Back cover: Train on Portage Bridge, artist unidentified, c. 1852-75
Back flap: Eagle, attributed to Wilhelm Schimmel, c. 1875-1890

Page 2: Archangel Gabriel Weathervane, artist unidentified, c. 1840,
Collection of the American Folk Art Museum, New York, NY

This book may be ordered by mail from the publisher.
But try your bookstore first!

Published by Courage Books, an imprint of
Running Press Book Publishers
125 South Twenty-second Street
Philadelphia, Pennsylvania 19103-4399

Visit us on the web!
www.runningpress.com

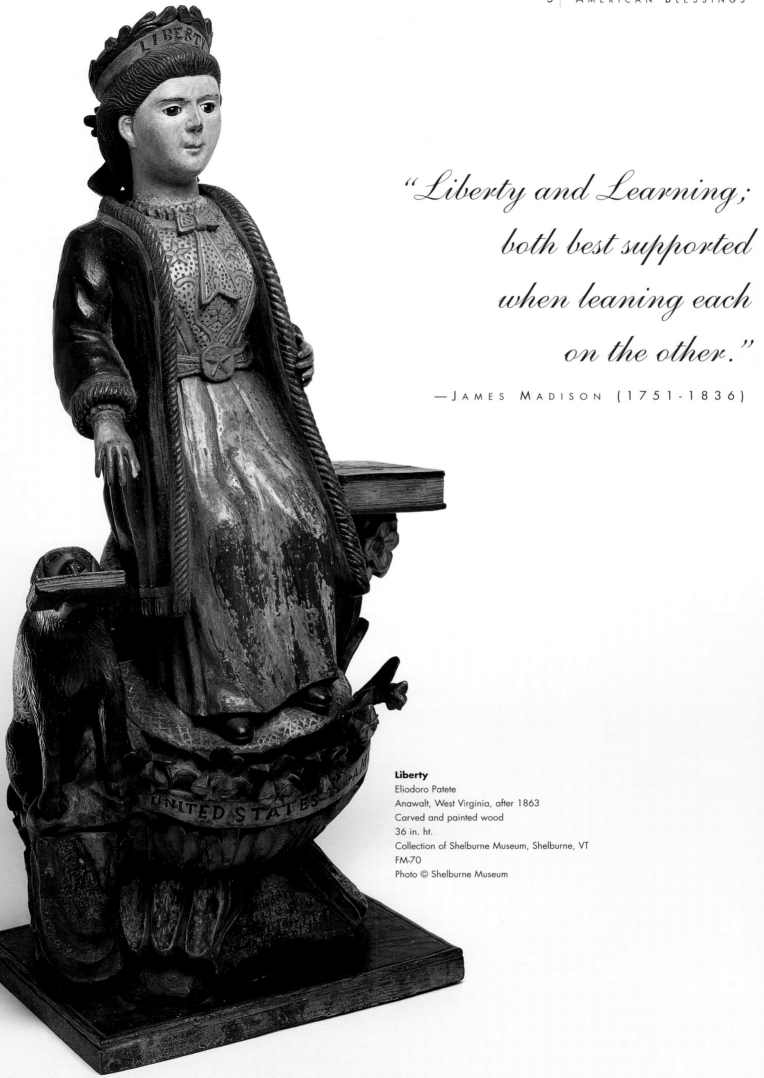

"Liberty and Learning;
both best supported
when leaning each
on the other."

—JAMES MADISON (1751-1836)

Liberty
Eliodoro Patete
Anawalt, West Virginia, after 1863
Carved and painted wood
36 in. ht.
Collection of Shelburne Museum, Shelburne, VT
FM-70
Photo © Shelburne Museum

"What a glorious morning for America!"
—SAMUEL ADAMS (1722-1803)

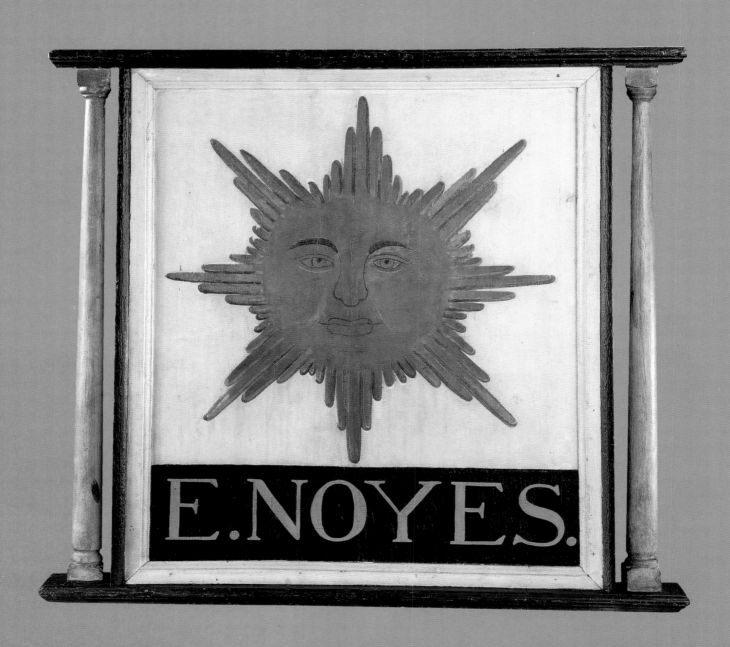

E. Noyes Trade Sign
Artist unidentified
Mid-19th century
Painted wood
30 x 33¾ x 3¼ in.
Collection of Shelburne Museum, Shelburne, VT
FT-51
Photo © Shelburne Museum

"Whatever else an American believes or disbelieves about himself, he is absolutely sure he has a sense of humor."

—E.B. WHITE (1899-1985)

Fish with Flag
Artist unidentified
Found in upstate New York
Trade sign fragment, painted wood and sheet iron
Mid-19th century
34 x 61 x ¾ in.
Collection of Shelburne Museum, Shelburne, VT
FT-80
Photo © Shelburne Museum

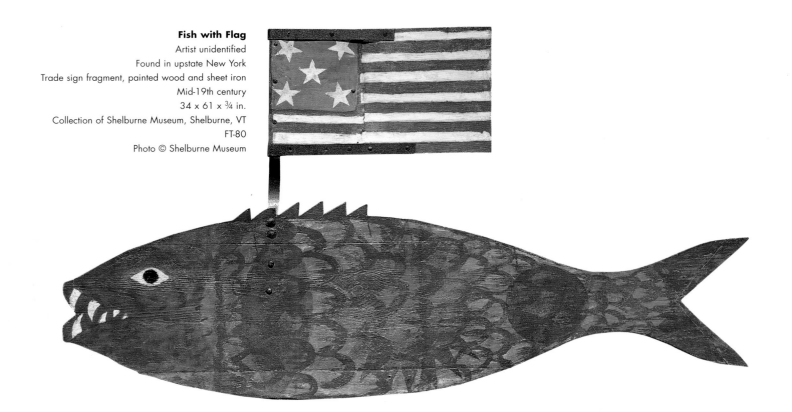

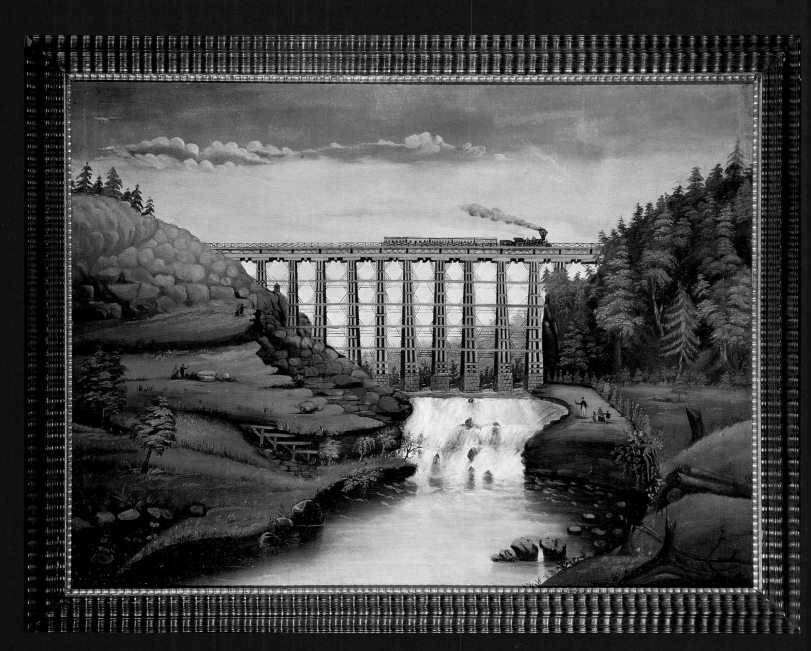

Train on Portage Bridge
Artist unidentified
Possibly New York State, c. 1852-1875
Oil on canvas
33 x 42 in.
Collection of Abby Aldrich Rockefeller Folk Art Museum, Williamsburg, VA
58.102.5

"AMERICA IS A LAND OF WONDERS, IN WHICH

EVERYTHING IS IN CONSTANT MOTION AND

EVERY CHANGE SEEMS AN IMPROVEMENT."

—ALEXIS DE TOCQUEVILLE (1805-1859)

"*In a chariot of light from the region of day, The Goddess of Liberty came. She brought in her hand as a pledge of her love, the plant she named Liberty Tree.*"

—THOMAS PAINE (1737-1809)

Statue of Liberty Weathervane
Artist unidentified
United States, c. 1886-1910
Copper and zinc
39¼ x 36¾ x 2½ in.
Collection of Abby Aldrich Rockefeller Folk Art Museum,
Williamsburg, VA
32.800.4

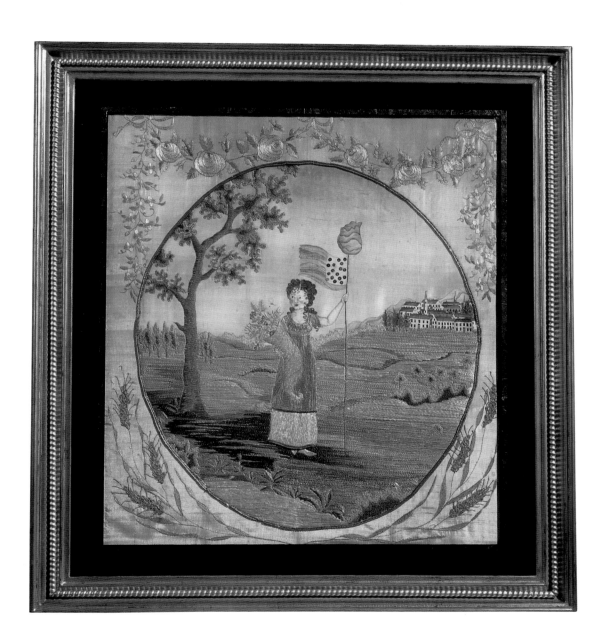

Liberty Needlework
Lucina Hudson (1787–?)
South Hadley, Hampshire County, Massachusetts, 1808
Watercolor and silk thread on silk, with metallic thread and spangles
18 x 16 in.
Collection of American Folk Art Museum, New York, NY
Museum purchase with funds from the Jean Lipman Fellows, 1996
1996.9.1

"*The* basis of our political system is the right of the people to make and alter their constitutions of government."

—George Washington (1732-1799)

Coverlet, detail
James Alexander (1770-1870)
Probably Newburgh, New York
Wool and cotton
76 x 94½ in.
Collection of Fenimore Art Museum, Cooperstown, NY
Photo by Glenn Linsenbardt

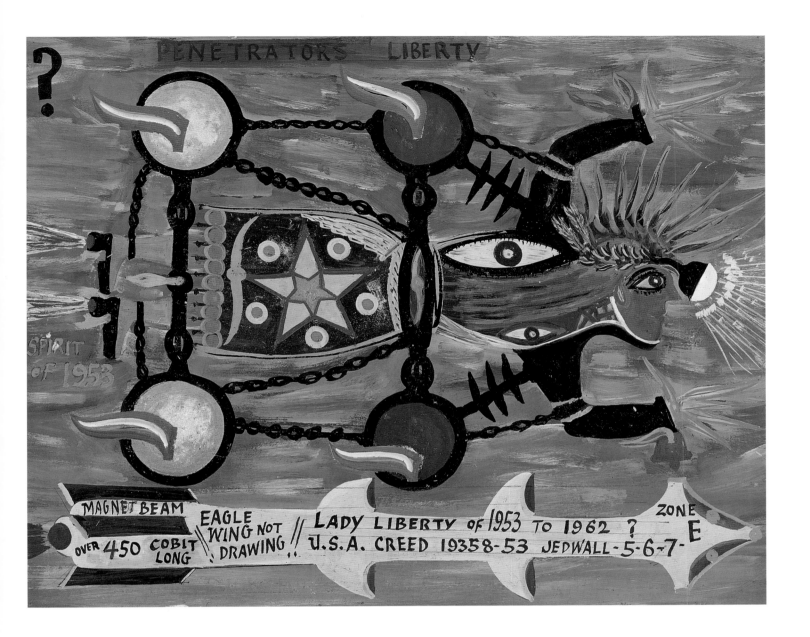

"*No member of our family* SHOULD BE SATISFIED IF ANY MEMBER OF OUR AMERICAN FAMILY IS SUFFERING OR IN NEED AND WE CAN DO SOMETHING ABOUT IT."

— COLIN POWELL, SECRETARY OF STATE (B. 1937)

Lady Liberty of 1953 to 1962
Peter Charlie Boshegan (d. 1962)
United States, c. 1962
22⅝ x 28½ in.
House paint and metallic paint on paper-board with pencil
Collection of Hemphill Collection, Smithsonian American Art Museum, Washington, D.C.
Photo © Smithsonian American Art Museum, Washington, D.C./Art Resource, NY

"Action is the antidote to despair."

—JOAN BAEZ (B. 1941)

Rosa Parks
Marshall D. Rumbaugh
United States, 1983
Painted limewood
32^{13}/$_{16}$ in. ht.
Collection of National Portrait Gallery, Smithsonian Institution
Washington, D.C.
Photo © National Portrait Gallery, Smithsonian Institution/Art Resource, NY

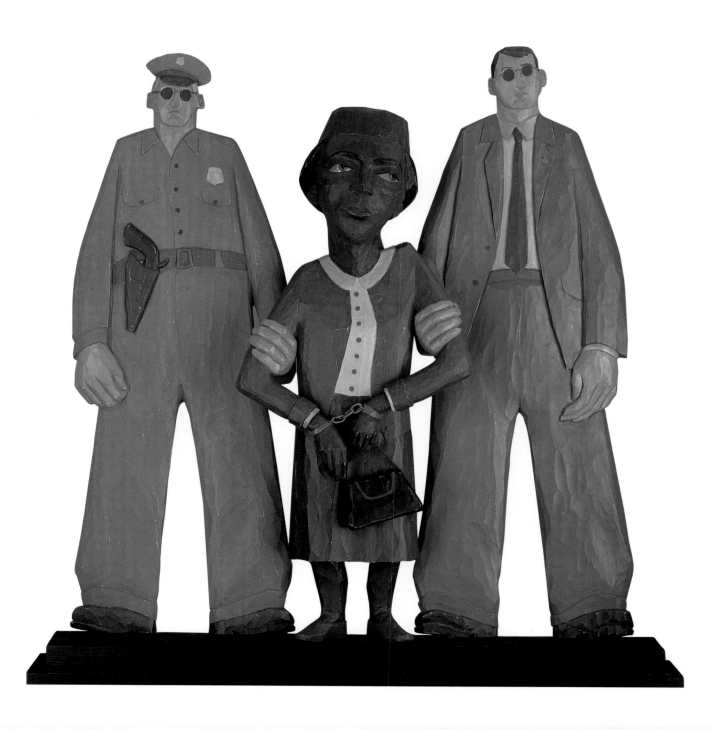

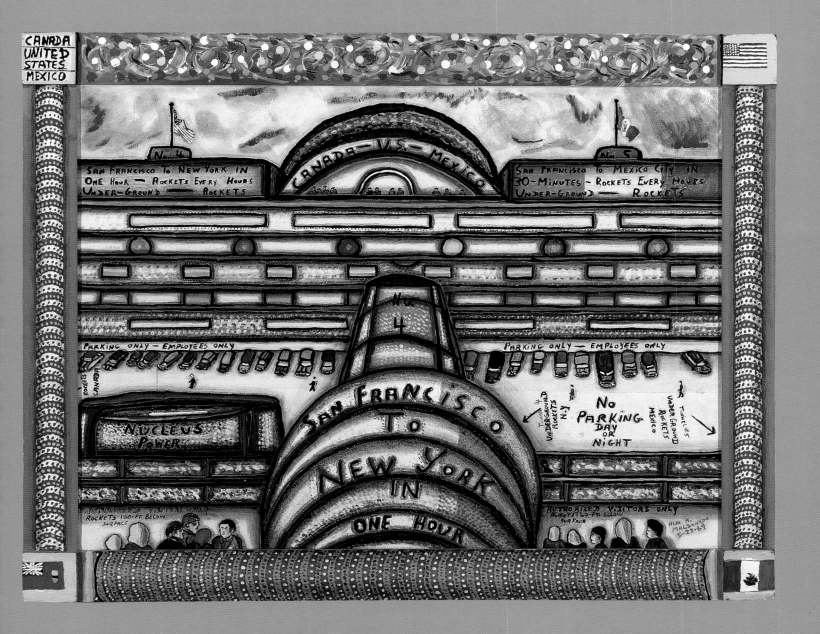

"THIS COUNTRY HAS FAR MORE PROBLEMS THAN IT DESERVES

AND FAR MORE SOLUTIONS THAN IT APPLIES."

—RALPH NADER, PRESIDENTIAL CANDIDATE (B. 1934)

San Francisco to New York in One Hour
Alexander Aramburo Maldonado (1901-1989)
United States, 1969
Oil on canvas with painted wood frame
Framed: 21½ x 27½ in.
Collection of Smithsonian American Art Museum, Washington, D.C.
Photo © Smithsonian American Art Museum, Washington, D.C./Art Resource, NY

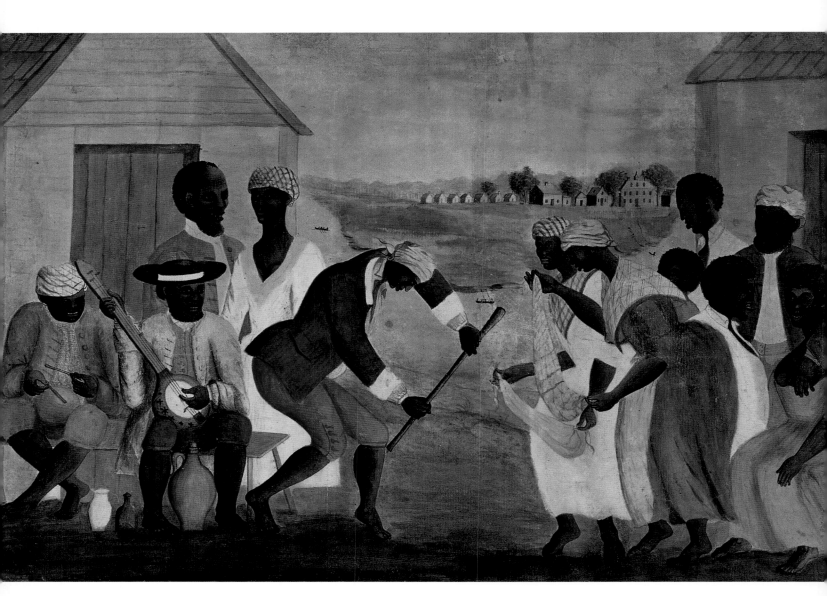

The Old Plantation
Artist unidentified
Probably South Carolina, c. 1790-1800
Watercolor on laid paper
11¹¹⁄₁₆ x 17⅞ in.
Collection of Abby Aldrich Rockefeller Folk Art Museum,
 Williamsburg, VA
35.301.3

"Now, I say to you today my friends, even though we face the difficulties of today and tomorrow, I still have a dream. It is a dream deeply rooted in the American dream . . . "

—MARTIN LUTHER KING, JR. (1929-1968)

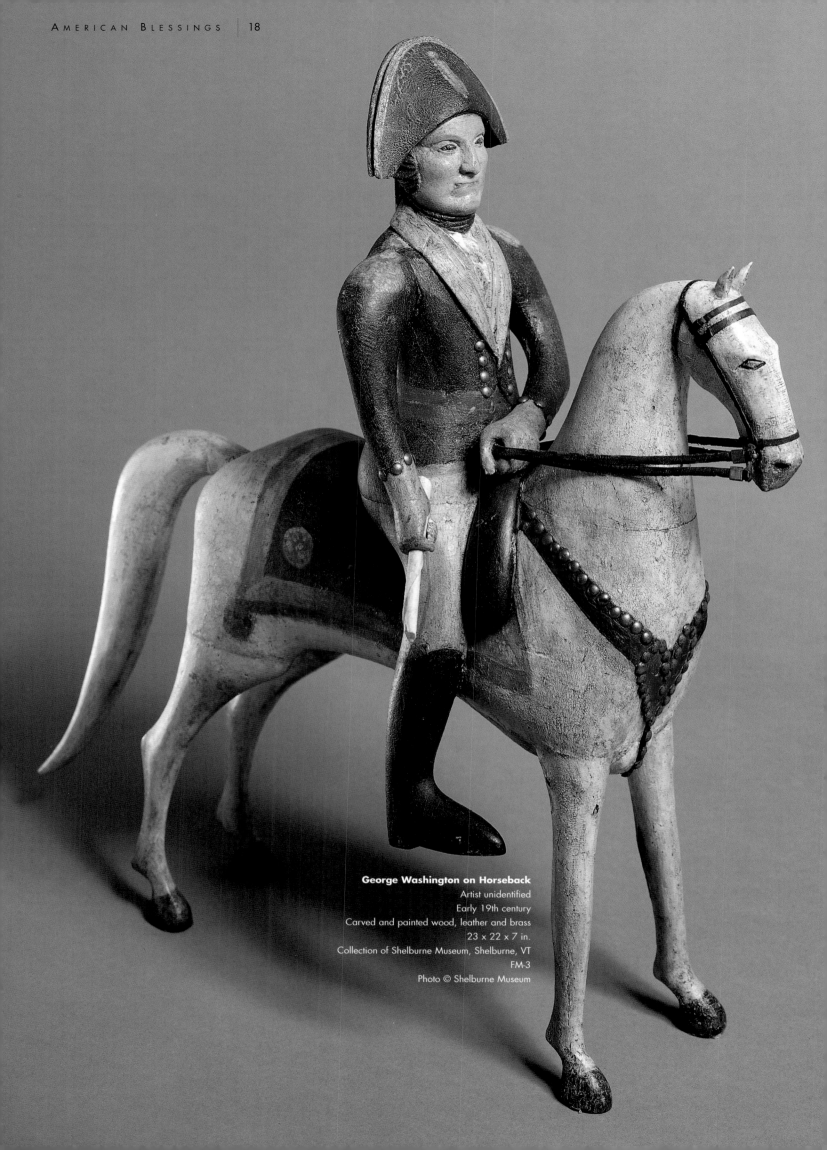

George Washington on Horseback
Artist unidentified
Early 19th century
Carved and painted wood, leather and brass
23 x 22 x 7 in.
Collection of Shelburne Museum, Shelburne, VT
FM-3
Photo © Shelburne Museum

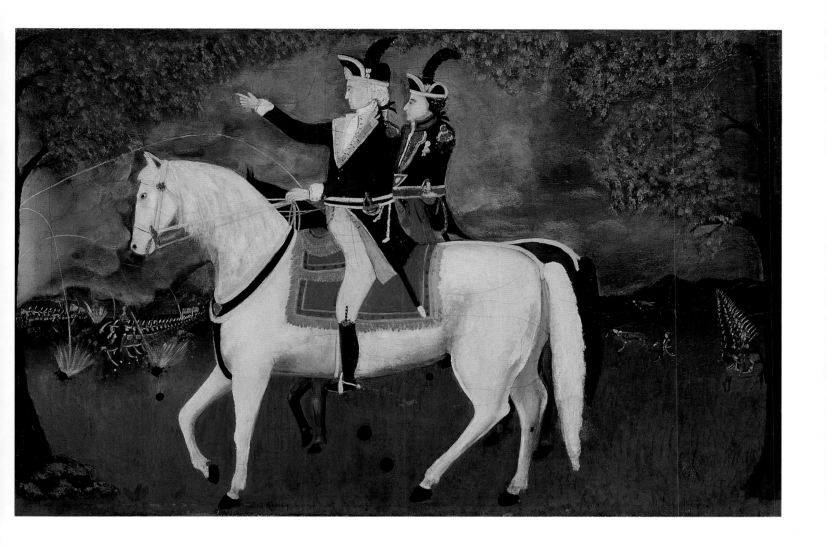

"America has furnished to the world the character of Washington. And if our American institutions had done nothing else, that alone would have entitled them to the respect of mankind."

—DANIEL WEBSTER (1782-1852)

Washington and Lafayette at the Battle of Yorktown
Ruben Law Reed (1841-1921)
Acton, Massachusetts, c. 1860-1880
Oil and gold paint on canvas
22¼ x 33⅞ in.
Collection of Abby Aldrich Rockefeller Folk Art Museum,
Williamsburg, VA
31.101.1

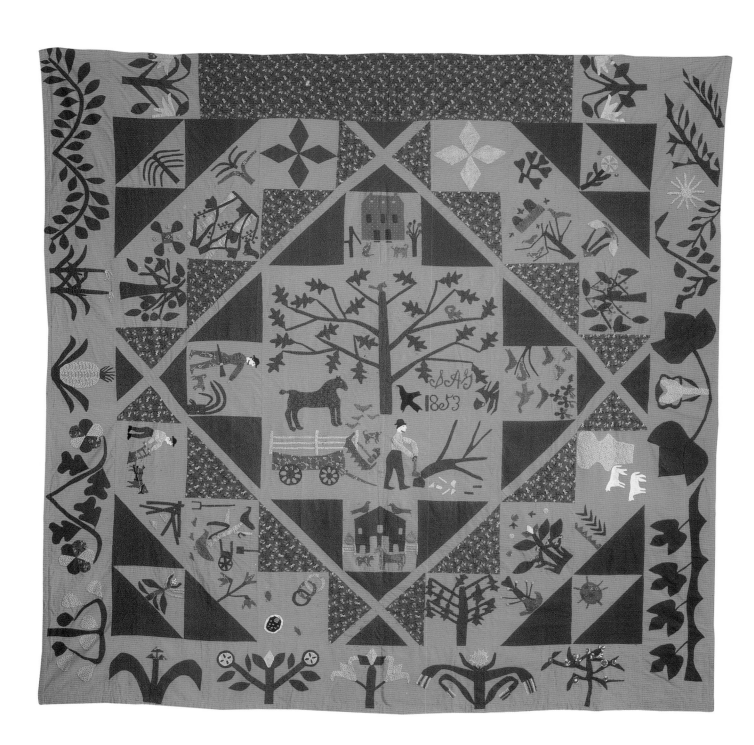

Sarah Ann Garges Appliqué Bedcover
Sarah Ann Garges (c. 1834–c.1887)
Doylestown, Bucks County, Pennsylvania, 1853
Cotton, silk, wool, and wool embroidery, with muslin backing
98 x 96 in.
Collection of American Folk Art Museum, New York
Gift of Warner Communications Inc.
1988.21.1
Photo by Schecter Lee, New York

"The work goes on, the cause endures, the hope still lives and the dreams shall never die."
—SENATOR EDWARD KENNEDY (D-MA)
(B. 1932)

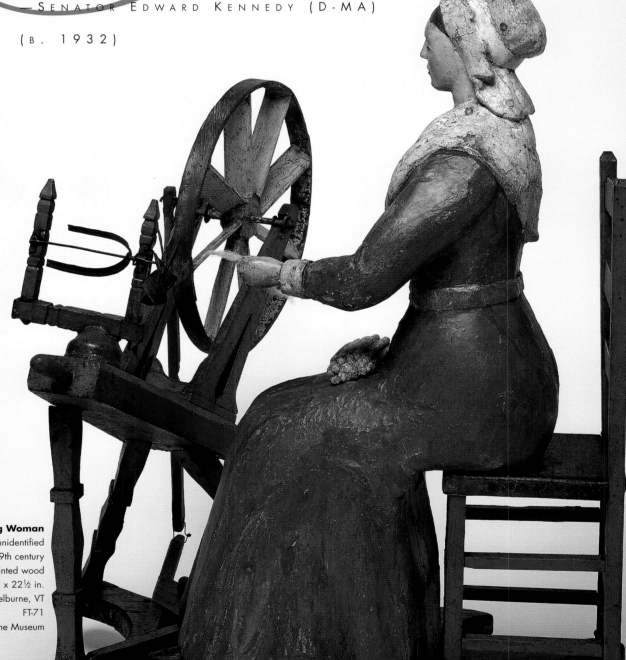

Spinning Woman
Artist unidentified
Late 19th century
Carved and painted wood
28 x 23½ x 22½ in.
Collection of Shelburne Museum, Shelburne, VT
FT-71
Photo © Shelburne Museum

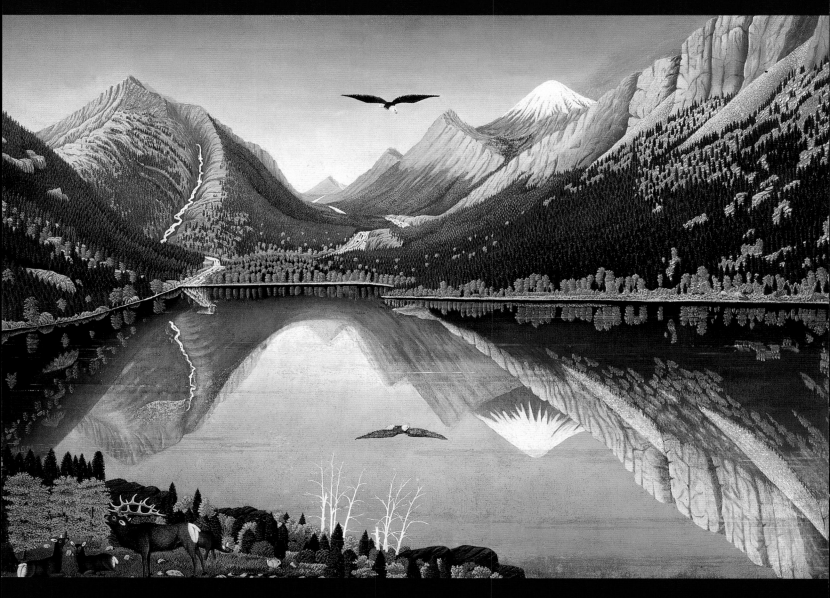

Wallowa Lake
Steve W. Harley (1863-1947)
Oregon, 1927-1928
Oil on canvas
24¾ x 36¼ in.
Collection of Abby Aldrich Rockefeller Folk Art Museum,
 Williamsburg, VA
57.102.4

H"HOW DEEP OUR SLEEP LAST NIGHT IN THE MOUNTAIN'S HEART, BENEATH THE TREES AND THE STARS, HUSHED BY SOLEMN-SOUNDING WATERFALLS AND MANY SOOTHING VOICES IN SWEET ACCORD WHISPERING PEACE! AND OUR FIRST PURE MOUNTAIN DAY, WARM, CALM, CLOUDLESS—HOW IMMEASURABLE IT SEEMS, HOW SERENELY WILD!"

—JOHN MUIR (1838-1914)

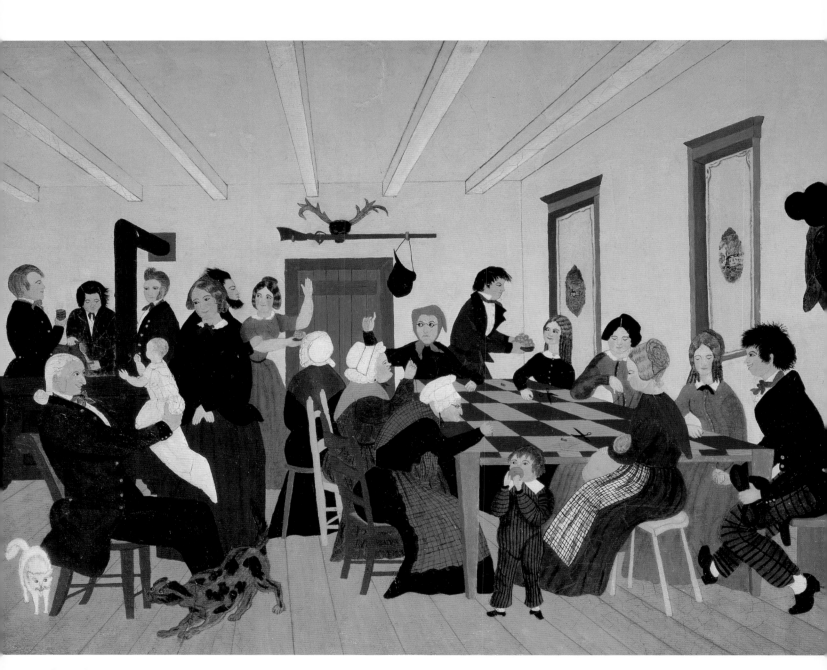

The Quilting Party
Artist unidentified
United States, c. 1854-1875
Oil and pencil on paper adhered to plywood
19¼ x 26 in.
Collection of Abby Aldrich Rockefeller Folk Art Museum,
 Williamsburg, VA
37.101.1

"The preservation of the sacred fire of liberty and the destiny of the republican model of government are justly considered . . . finally, staked on the experiment entrusted to the hands of the American people."

—GEORGE WASHINGTON (1732-1799)

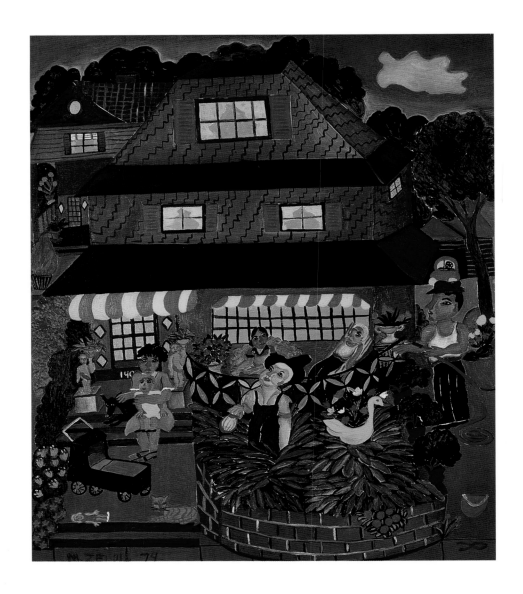

What the people want IS VERY SIMPLE. THEY WANT AN AMERICA AS GOOD AS ITS PROMISE."

— REP. BARBARA JORDAN (D-TX)

(1936-1996)

Front Porch, Brooklyn
Malcah Zeldis (b. 1931)
New York City. 1979
Oil on board
18 x 24 in.
Private collection

Musician with Lute
Clark Coe (1847-1919)
Killingtowth, Middlesex County, Connecticut, c. 1900
Paint on pine and ash with metal
30 x 19 x 22 in.
Collection of American Folk Art Museum, New York, NY
Gift of the Museum of Modern Art from the collection of Gordon
and Nina Bunshaft
1995.1.1
Photo by Gavin Ashworth, New York

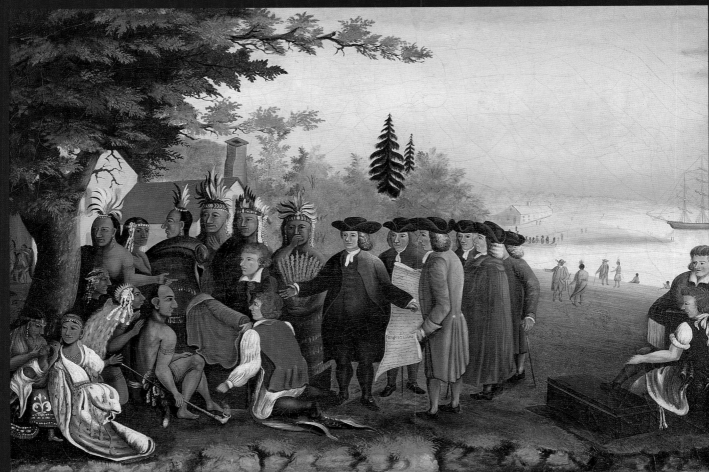

Penn's Treaty with the Indians
Edward Hicks (1780-1849)
Bucks County, Pennsylvania, c. 1840
Oil on canvas
36¼ x 31 in.
Collection of Shelburne Museum, Shelburne, VT
27.1.6-1
Photo © Shelburne Museum

"He who believes is strong; he who doubts is weak. Strong convictions precede great actions."

—LOUISA MAY ALCOTT (1832-1888)

Statue of Liberty Hanukkah Lamp
Mae Rockland Tupa (b. 1937)
Brookline, MA, 1974
Wood covered in fabric with molded plastic figures
11 x 36 x 7 in.
Collection of The Jewish Museum, New York, NY
Photo © The Jewish Museum, NY/Art Resource, NY

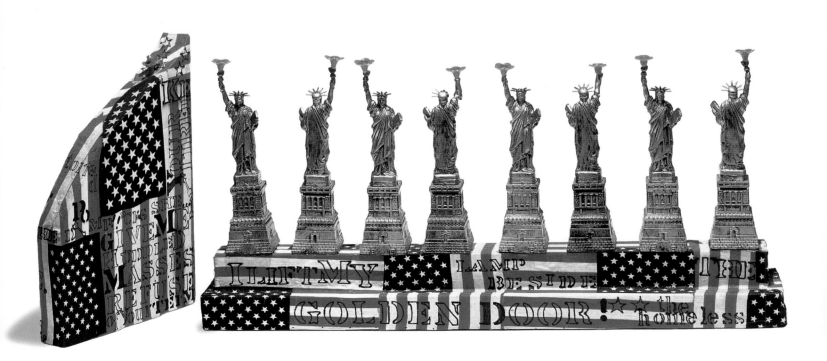

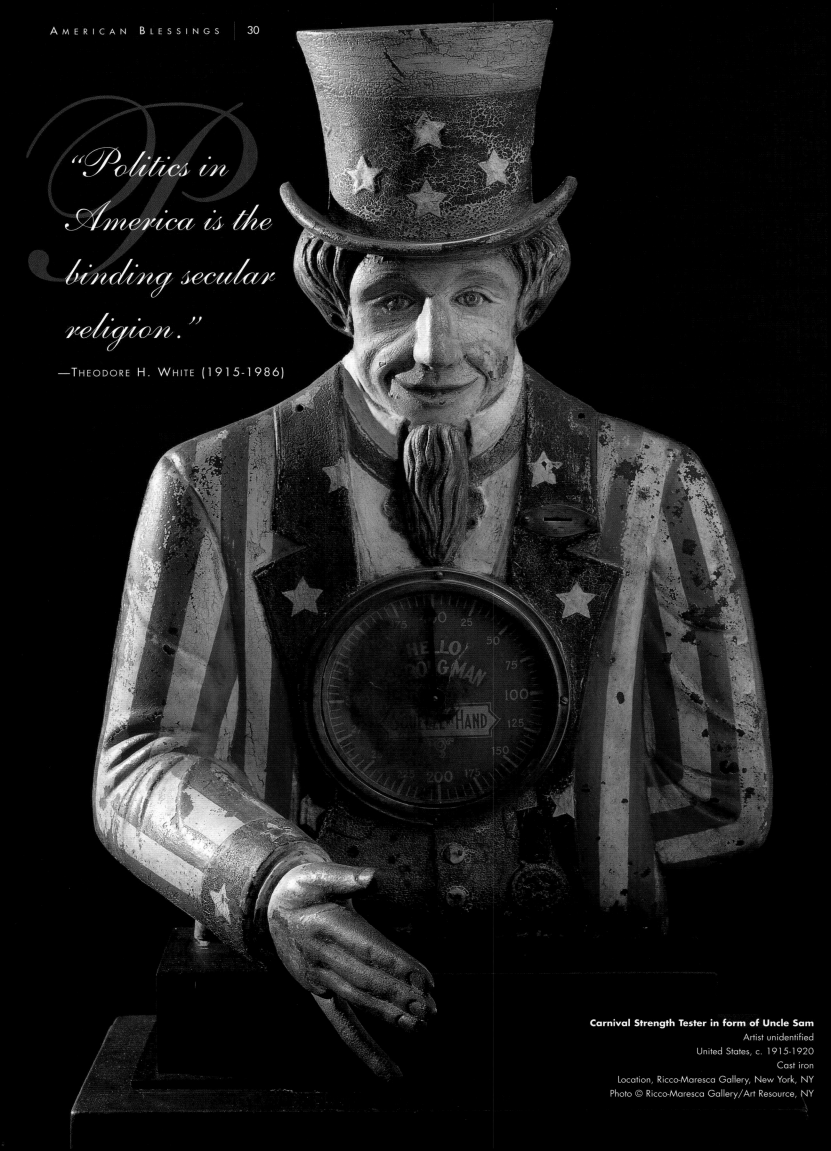

"Politics in America is the binding secular religion."

—THEODORE H. WHITE (1915-1986)

Carnival Strength Tester in form of Uncle Sam
Artist unidentified
United States, c. 1915-1920
Cast iron
Location, Ricco-Maresca Gallery, New York, NY
Photo © Ricco-Maresca Gallery/Art Resource, NY

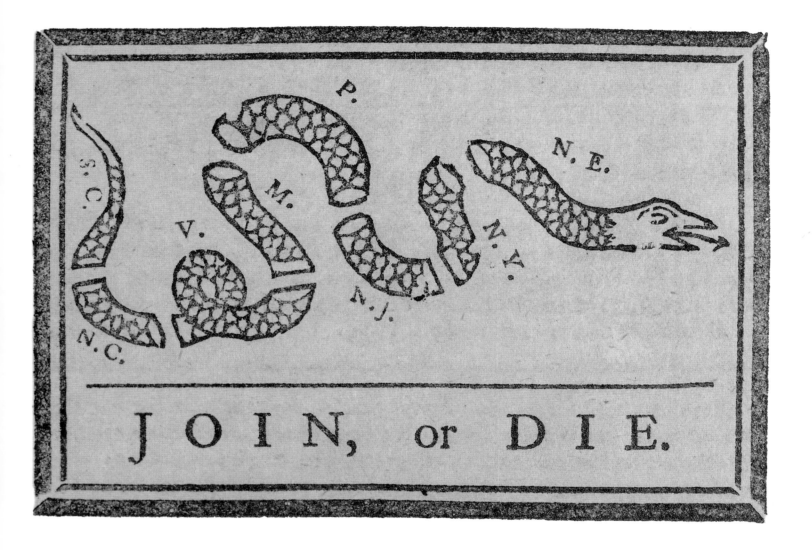

"Then join hand, BRAVE AMERICA ALL, BY UNITING WE STAND, BY DIVIDING WE FALL."

—JOHN DICKINSON (1732-1808)

Join or Die
Artist unidentified
Published by Ben Franklin, Pennsylvania Gazette, Philadelphia, May 9, 1754
Wood cut on paper
2 x 2⅞ in.
Collection of the Library Company of Philadelphia, Philadelphia, PA
Photo by Will Brown

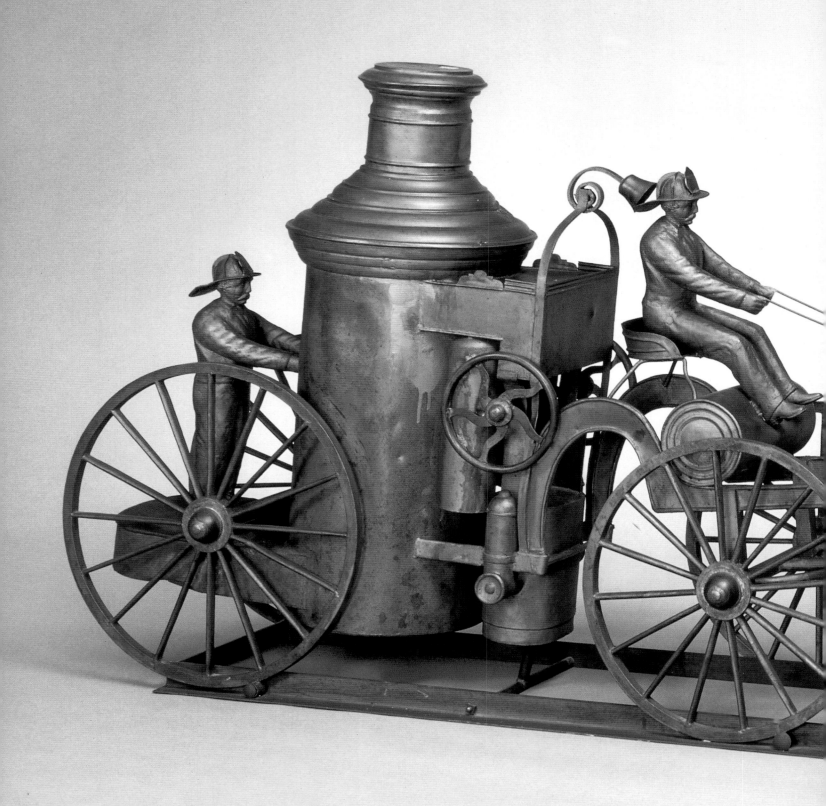

"Take time to deliberate;
but when the time for action
arrives, stop thinking and go in."
— ANDREW JACKSON (1767-1845)

Fire Engine Weathervane
Attributed to J.W. Fiske Company
New York City, Late 19th century
Copper and other metals (brass, zinc, and iron)
37 x 88¾ x 16½ in.
Collection of Shelburne Museum, Shelburne, VT
FW-35
Photo © Shelburne Museum

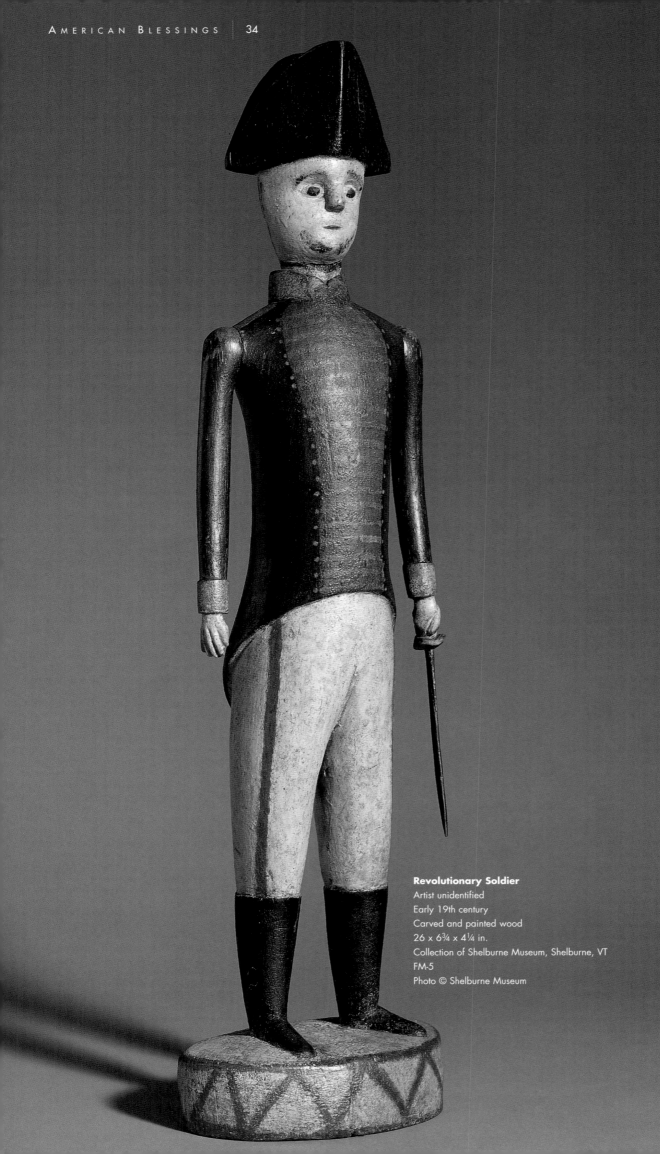

Revolutionary Soldier
Artist unidentified
Early 19th century
Carved and painted wood
26 x 6¾ x 4¼ in.
Collection of Shelburne Museum, Shelburne, VT
FM-5
Photo © Shelburne Museum

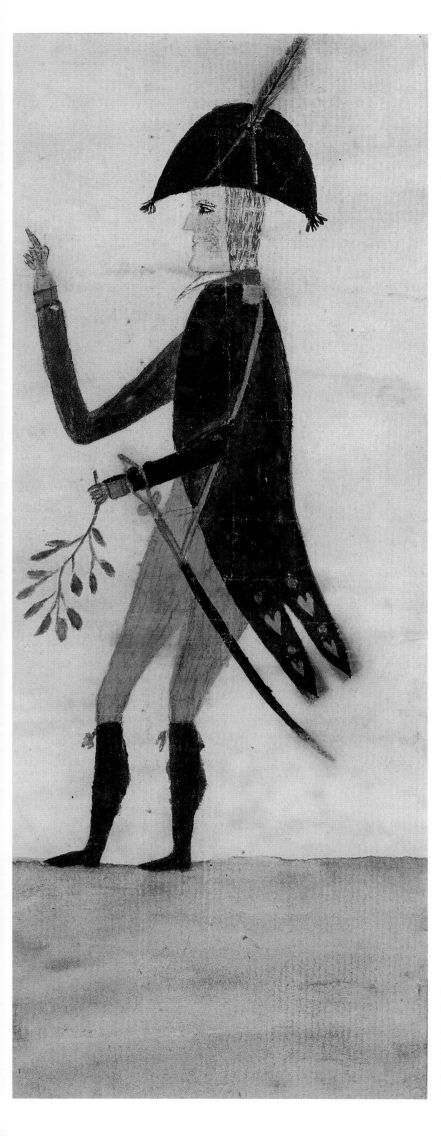

"If the American Revolution had produced nothing but the Declaration of Independence, it would have been worthwhile."

—SAMUEL ELIOT MORISON

(1887-1976)

Officer of the American Revolution
Artist unidentified
1775-1780
Watercolor on paper
8 1/16 x 3 1/4 in.
Collection of Shelburne Museum, Shelburne, VT
27.2.1-4
Photo © Shelburne Museum

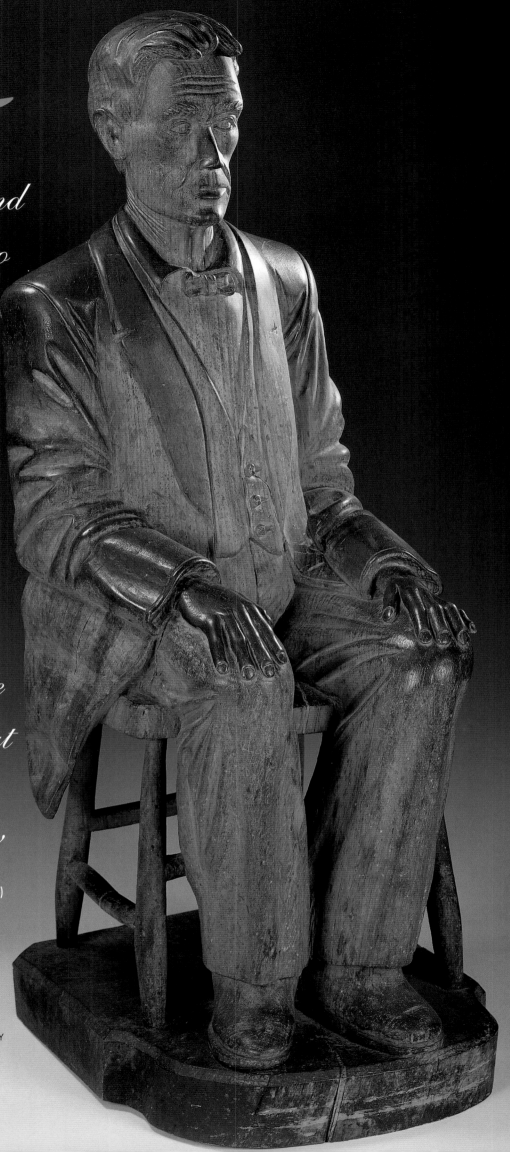

"Four score and seven years ago our fathers brought forth on this continent a new nation, conceived in liberty, and dedicated to the proposition that all men are created equal."

—ABRAHAM LINCOLN (1809-1865)

Abraham Lincoln
Frank Moran (1877-1967)
Bakersfield, Vermont, c. 1940-1945
Pine
55 x 21 x 23½ in.
Collection of Fenimore Art Museum, Cooperstown, NY
Photo by Richard Walker

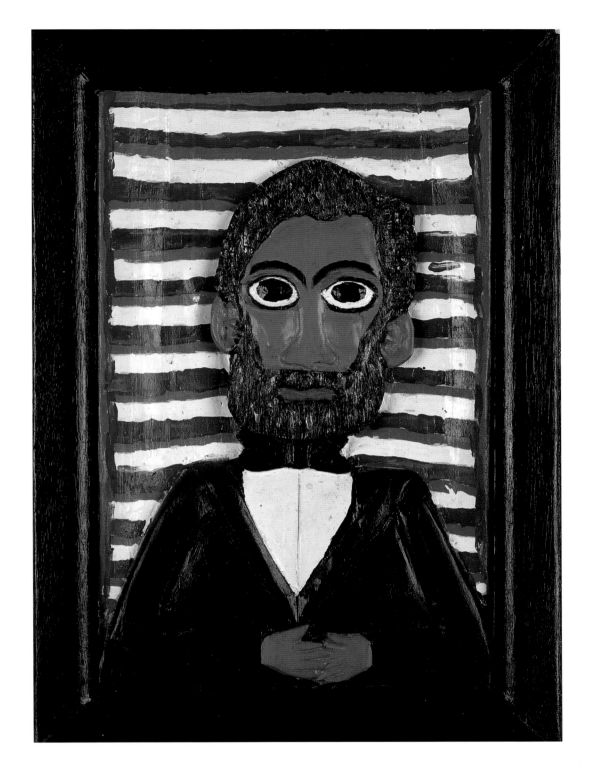

"*A great man,* TENDER OF HEART, STRONG OF NERVE, BOUNDLESS PATIENCE AND

BROADEST SYMPATHY, WITH NO MOTIVE APART FROM HIS COUNTRY."

—FREDERICK DOUGLASS (1817-1895)

ON ABRAHAM LINCOLN

Abraham Lincoln
Elijah Pierce (1892-1984)
Columbus, Ohio, c. 1975
Carved and painted wood relief
14½ x 9¼ in.
Collection of the American Folk Art Museum, New York, NY
Gift of Robert Bishop
1993.4.39

"AMERICA HAS NEVER FORGOTTEN

—AND WILL NEVER FORGET

—THE NOBLER THINGS THAT BROUGHT

HER INTO BEING AND

THAT LIGHT HER PATH."

—BERNARD MANNES BARUCH (1870-1965)

Eagle and Shield Weathervane
Artist unidentified
Massachusetts, c. 1800
Cast bell metal
36 x 43½ x 4 in.
Collection of American Folk Art Museum, New York, NY
Gift of Mr. and Mrs. Francis S. Andrews
1982.6.4
Photo John Parnell, New York

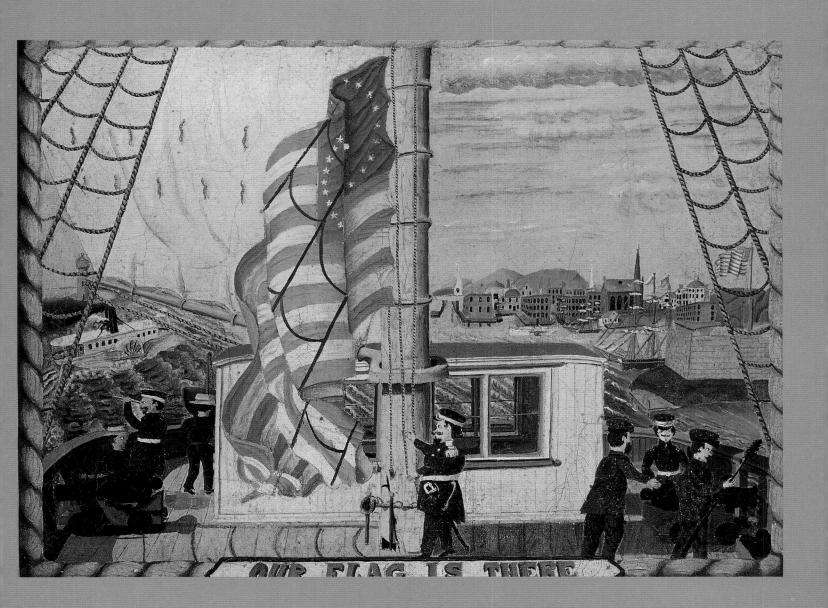

"Never give in and never give up."

—HUBERT H. HUMPHREY (1911-1978)

Our Flag is There
Artist unidentified
19th century
Oil on canvas
15 x 19½ in.
Collection of Shelburne Museum, Shelburne, VT
27.1.4-68
Photo © Shelburne Museum

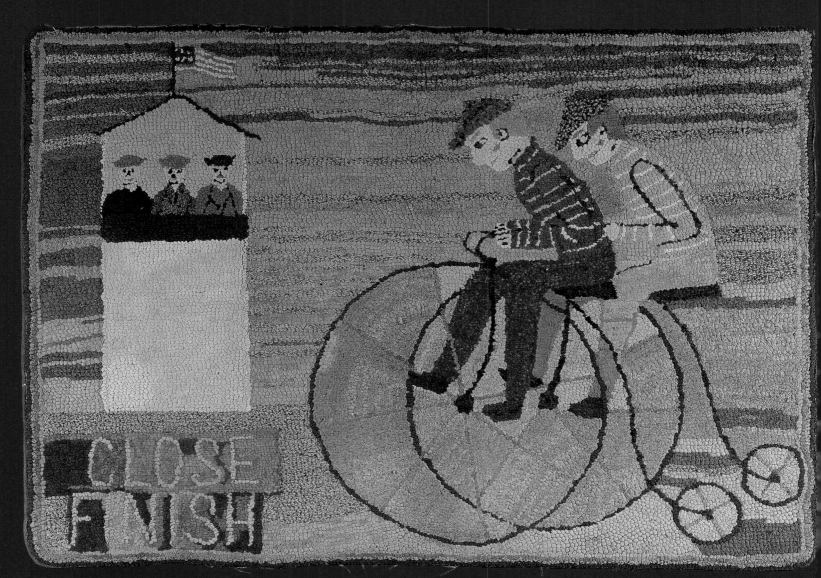

Close Finish Hooked Rug
Artist unidentified
United States, early 20th century
Wool and burlap with cotton binding
32½ x 46 in.
Collection of American Folk Art Museum, New York, NY
Bequest of Gertrude Schweitzer
1990.28.2
Photo by Gavin Ashworth, New York

"NO MATTER HOW HARD THE LOSS,

DEFEAT MIGHT SERVE AS WELL AS VICTORY

TO SHAKE THE SOUL AND LET THE GLORY OUT."

—AL GORE, FORMER VICE PRESIDENT (B. 1948)

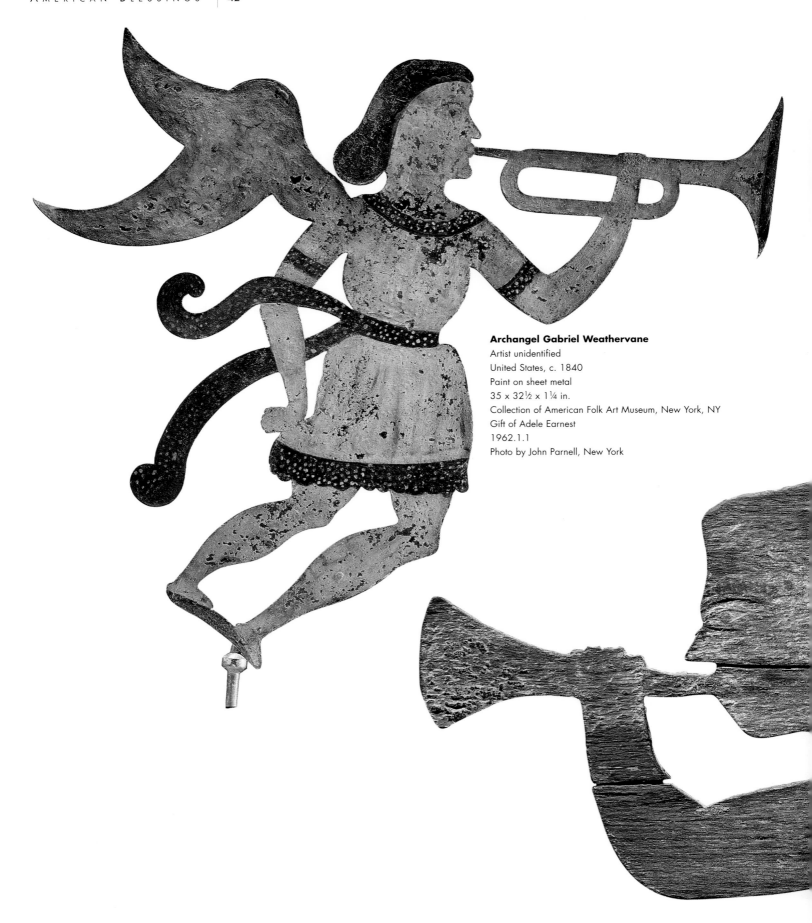

Archangel Gabriel Weathervane
Artist unidentified
United States, c. 1840
Paint on sheet metal
35 x 32½ x 1¼ in.
Collection of American Folk Art Museum, New York, NY
Gift of Adele Earnest
1962.1.1
Photo by John Parnell, New York

"*Character is doing the right thing*

WHEN NO ONE IS WATCHING."

—REPRESENTATIVE J.C. WATTS (R-CA)

(B. 1957)

Angel Gabriel Weathervane
Artist unidentified
19th century
Carved and painted wood
13 x 33½ x½ in.
Collection of Shelburne Museum, Shelburne, VT
FW-2
Photo © Shelburne Museum

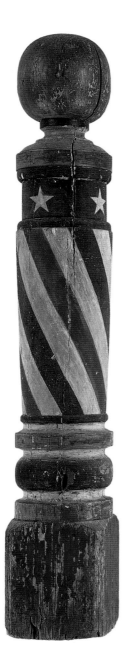

"The cement of this Union is the heart-blood of every American. I do not believe there is on earth a government established on so immovable a basis."

—THOMAS JEFFERSON (1743-1826)

Barber Pole
Artist unidentified
United States
Wooden pole, painted
60 in. ht.
Collection of Fenimore Art Museum, Cooperstown,
New York, NY
Photo by Richard Walker

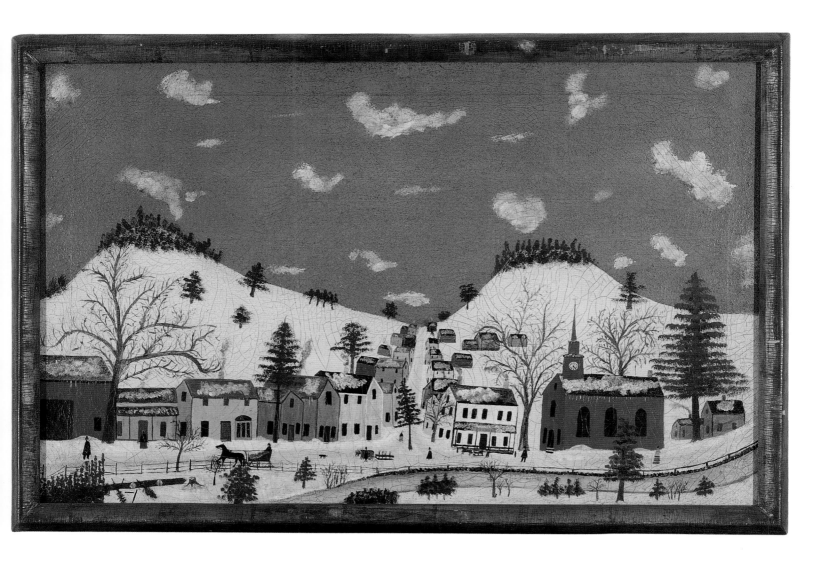

From "American Feuillage" by Walt Whitman (1819-1892)

AMERICA ALWAYS! ALWAYS OUR OWN FEUILLAGE! ALWAYS FLORIDA'S GREEN PENINSULA! ALWAYS THE PRICELESS DELTA OF LOUISIANA! ALWAYS THE COTTON-FIELDS OF ALABAMA AND TEXAS! ALWAYS CALIFORNIA'S GOLDEN HILLS AND HOLLOWS —AND THE SILVER MOUNTAINS OF NEW MEXICO! ALWAYS SOFT-BREATH'D CUBA! ALWAYS THE VAST SLOPE DRAIN'D BY THE SOUTHERN SEA—INSEPARABLE WITH THE SLOPES DRAIN'D BY THE EASTERN AND WESTERN SEAS; THE AREA THE EIGHTY-THIRD YEAR OF THESE STATES—THE THREE AND A HALF MILLIONS OF SQUARE MILES; THE EIGHTEEN THOUSAND MILES OF SEA-COAST AND BAY-COAST ON THE MAIN—THE THIRTY THOUSAND MILES OF RIVER NAVIGATION, THE SEVEN MILLIONS OF DISTINCT FAMILIES, AND THE SAME NUMBER OF DWELLINGS—ALWAYS THESE, AND MORE, BRANCHING FORTH INTO NUMBERLESS BRANCHES; ALWAYS THE FREE RANGE AND DIVERSITY! ALWAYS THE CONTINENT OF DEMOCRACY!

American Landscape
L. Whitney
United States, c. 19th century
Oil on canvas
17¾ x 28 in.
Collection of The Newark Museum, Newark, NJ
31.149
Photo © The Newark Museum/Art Resource, NY

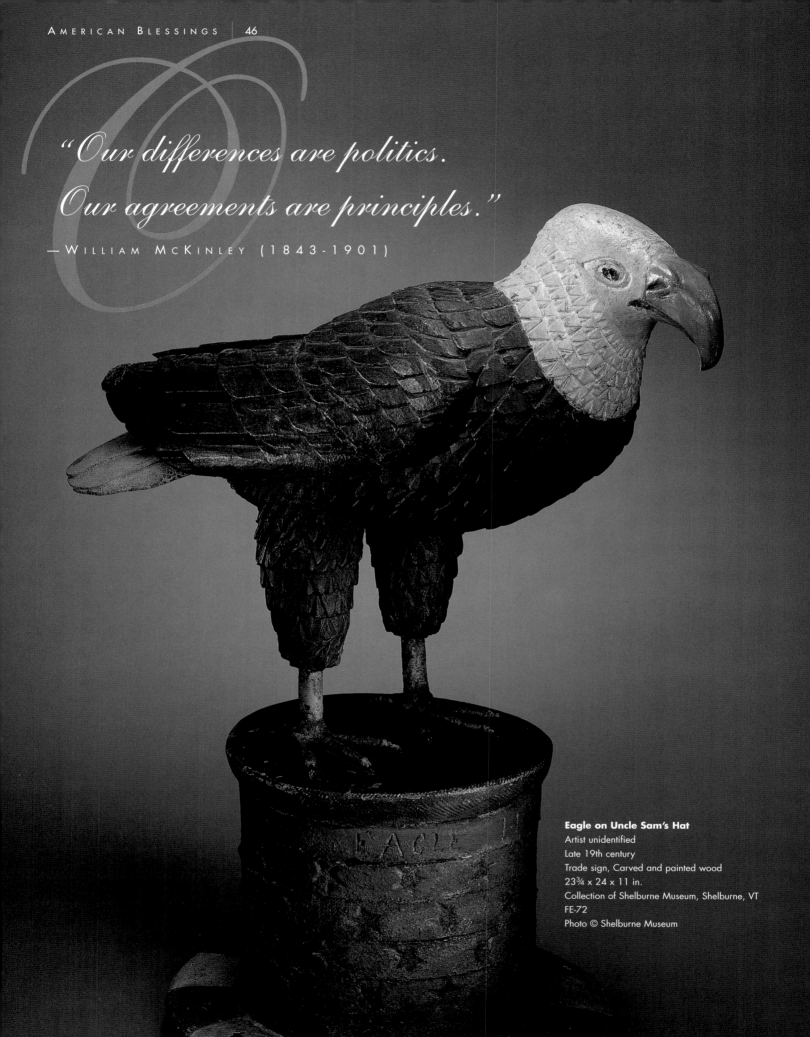

"*Our differences are politics.*
Our agreements are principles."
—WILLIAM MCKINLEY (1843-1901)

Eagle on Uncle Sam's Hat
Artist unidentified
Late 19th century
Trade sign, Carved and painted wood
23¾ x 24 x 11 in.
Collection of Shelburne Museum, Shelburne, VT
FE-72
Photo © Shelburne Museum

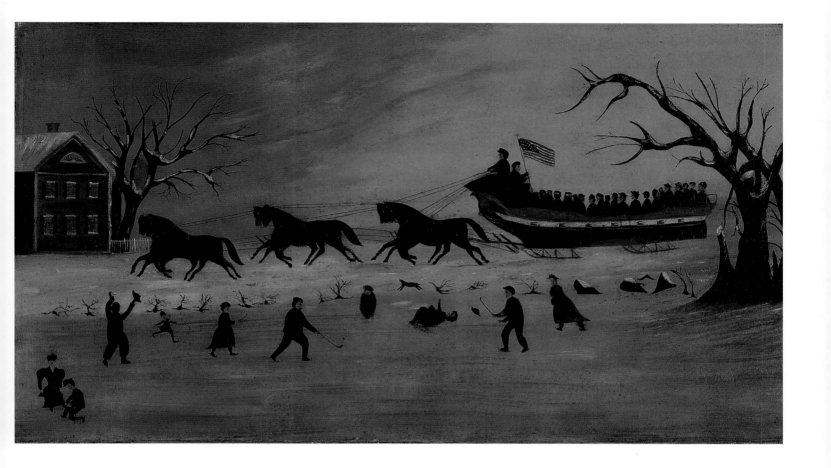

"Liberty lies in the hearts of men and women."

—LEARNED HAND (1872-1961)

Suffragettes Taking a Sleigh Ride
Artist unidentified
1870-1890
Oil on canvas
29¼ x 45½ in.
Collection of Shelburne Museum, Shelburne, VT
27.1.5-25
Photo © Shelburne Museum

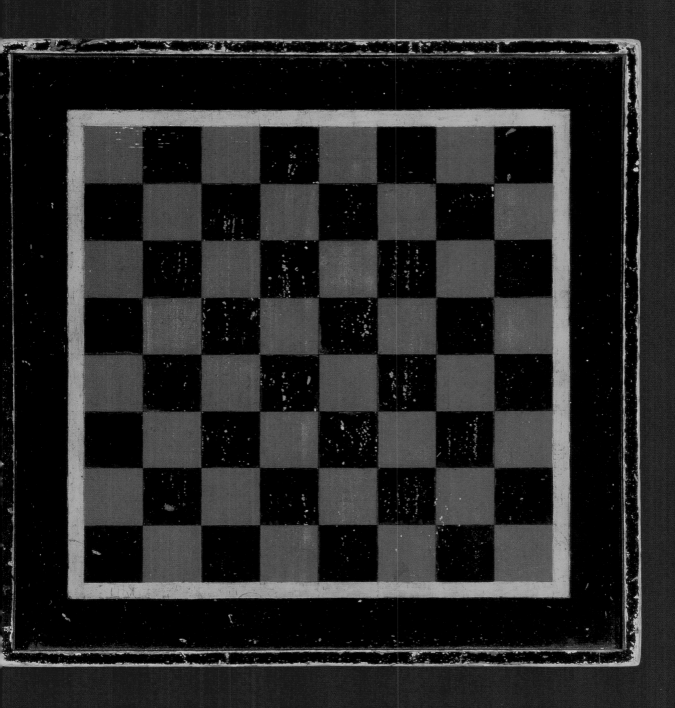

"*If* you're going to play the game properly, you'd better know every rule."

—Rep. Barbara Jordan (D-TX) (1936-1996)

Checkerboard / Mill Game (Nine Men's Morris)
Artist unidentified
United States, late 19th century
Paint on wood
19¼ x 18⅞ x 1½ in.
Collection of American Folk Art Museum, New York, NY
Gift of Cyril Irwin Nelson
1994.7.2
Photo by Gavin Ashworth, New York

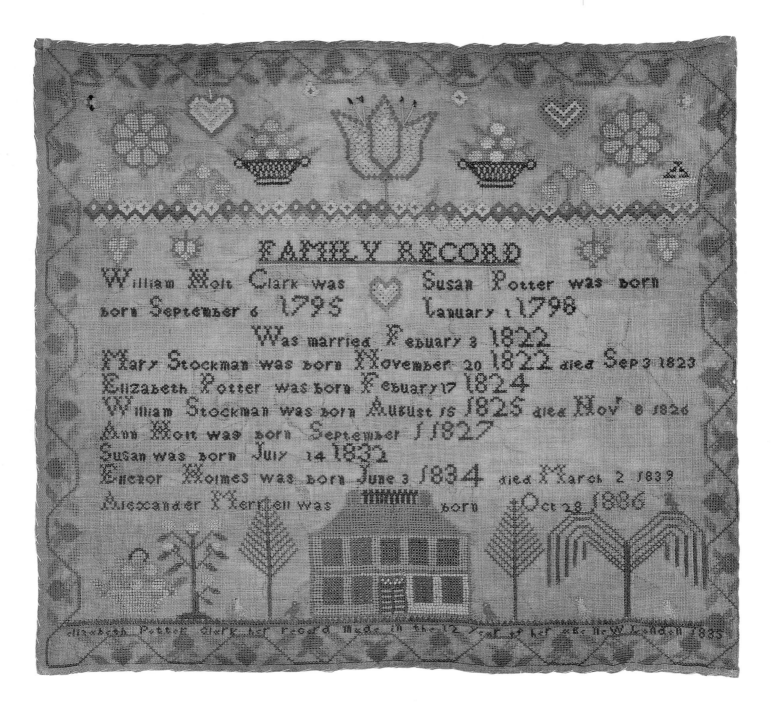

"*America* IS A FAMILY."

—COLIN POWELL, SECRETARY OF STATE (B. 1937)

Clark-Potter Family Record
Elizabeth Potter Clark (1824-1898)
New London, Connecticut, 1835
Silk embroidery on a linen or cotton ground
15¾ x 16¼ in.
Collection of Abby Aldrich Rockefeller Folk Art Museum,
Williamsburg, VA
58.605.1

"*In the beginning,
all the world was America.*"

—JOHN LOCKE, 17TH CENTURY (1632-1704)

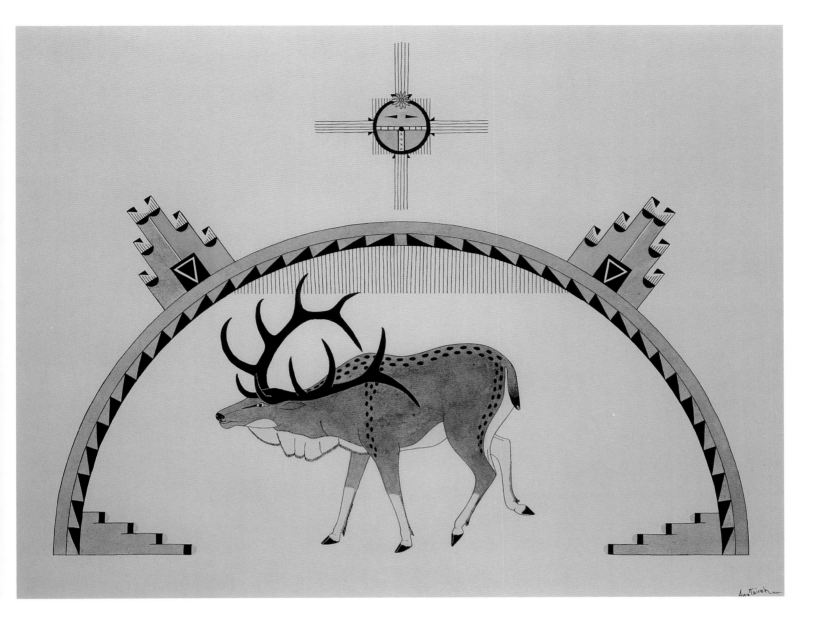

Elk
Tsireh Awa (1895-1985)
United States, c. 1925-1930
Watercolor and ink on paper
11¼ x 14¼ in.
Collection of Smithsonian American Art Museum, Washington, D.C.
Photo © Smithsonian American Art Museum, Washington, D.C./Art Resource, NY

TOTE Weathervane
Artist unidentified
19th century
Painted sheet iron
51 x 32 x 1¾ in.
Collection of Shelburne Museum, Shelburne, VT
FW-4
Photo © Shelburne Museum

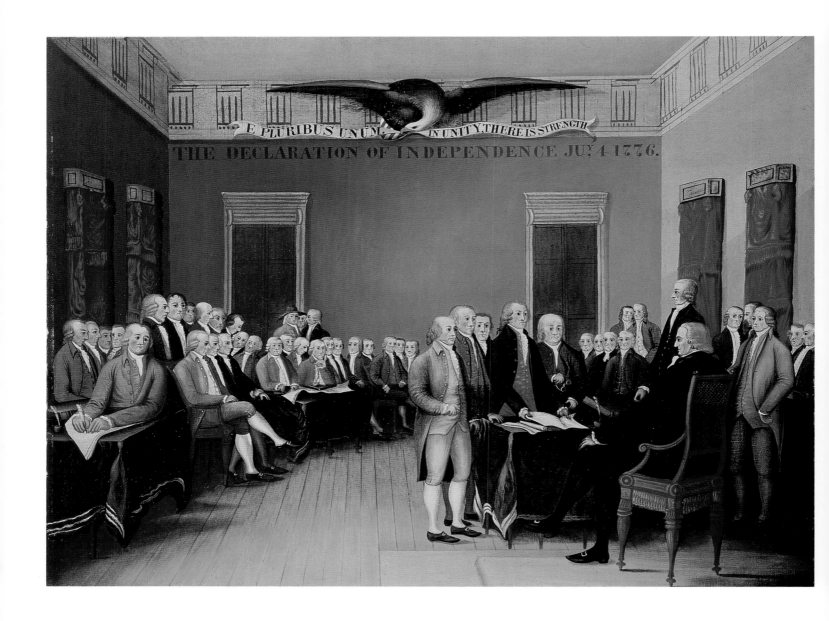

"*We hold these truths* TO BE SELF-EVIDENT, THAT ALL MEN ARE CREATED EQUAL,

THAT THEY ARE ENDOWED BY THEIR CREATOR WITH CERTAIN INALIENABLE RIGHTS, THAT

AMONG THESE ARE LIFE, LIBERTY, AND THE PURSUIT OF HAPPINESS."

— THE DECLARATION OF INDEPENDENCE

Declaration of Independence
Attributed to Edward Hicks (1780-1849) after John Trumbull
Bucks County, Pennsylvania, 1840-1844
Oil on canvas
24 x 34¾ in.
Collection of Abby Aldrich Rockefeller Folk Art Museum,
Williamsburg, VA
57.101.7

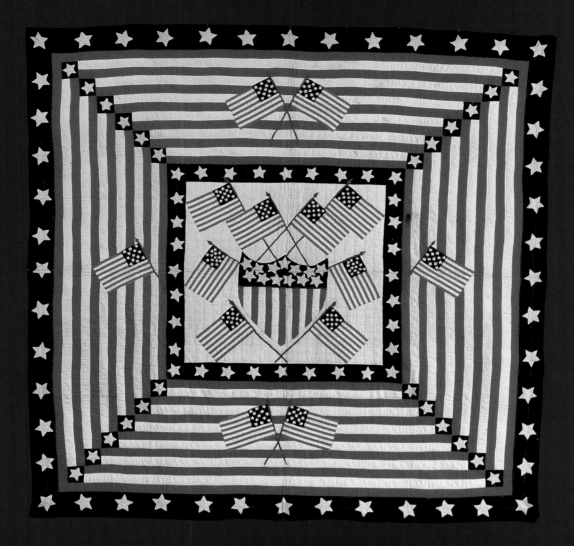

"A thoughtful mind, when it sees a Nation's flag, sees not the flag only, but the Nation itself; and whatever may be its symbols, its insignia, he reads chiefly in the flag the Government, the principles, the truths, the history which belongs to the Nation that sets it forth."

—HENRY WARD BEECHER (1813-1887),

FROM *THE AMERICAN FLAG*

Flag Quilt
Mary C. Baxter (dates unknown)
Kearny, Hudson County, New Jersey, 1898-1910
Cotton with cotton embroidery
77¼ x 78¾ in.
Collection of American Folk Art Museum, New York
Gift of the Americus Foundation, Inc., Anne Baxter Klee, and Museum
Trustees
1985.15.1

"Intellectually I know that America is no better than any other country; emotionally I know she is better than every other country."

—SINCLAIR LEWIS (1885-1951)

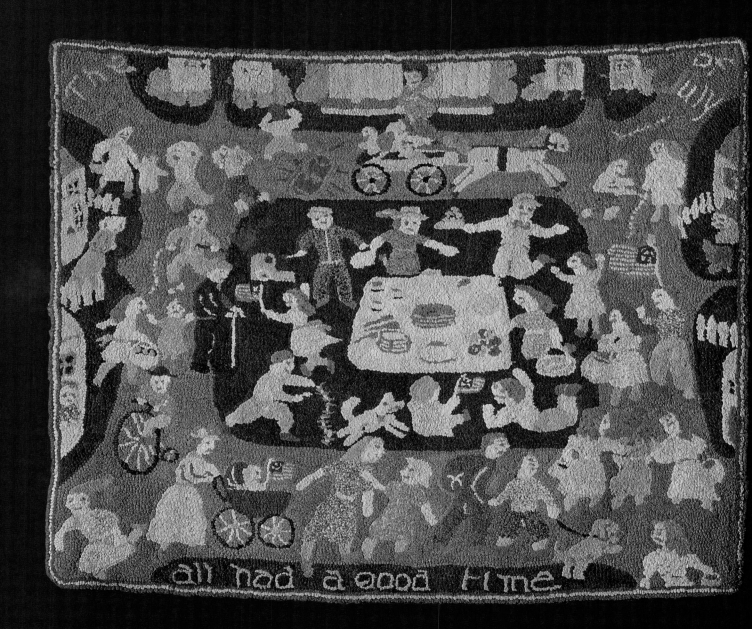

Fourth of July Hooked Rug
Artist unidentified
c. 1940
Wool, cotton and nylon hooked on burlap ground
37½ x 45½ in.
Collection of Shelburne Museum, Shelburne, VT
9-M-48
Photo © Shelburne Museum

"A single good government BECOMES . . .

A BLESSING TO THE WHOLE EARTH."

—THOMAS JEFFERSON (1743-1826)

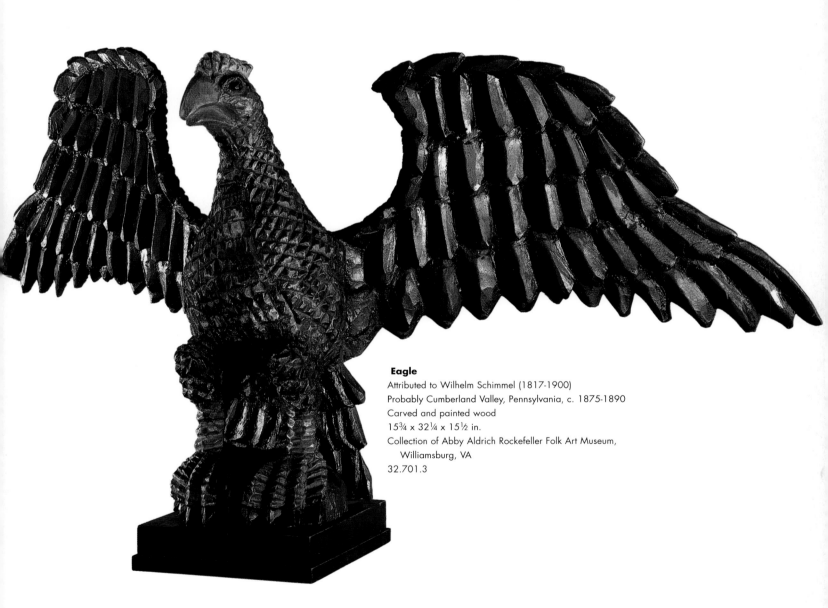

Eagle
Attributed to Wilhelm Schimmel (1817-1900)
Probably Cumberland Valley, Pennsylvania, c. 1875-1890
Carved and painted wood
15¾ x 32¼ x 15½ in.
Collection of Abby Aldrich Rockefeller Folk Art Museum,
 Williamsburg, VA
32.701.3

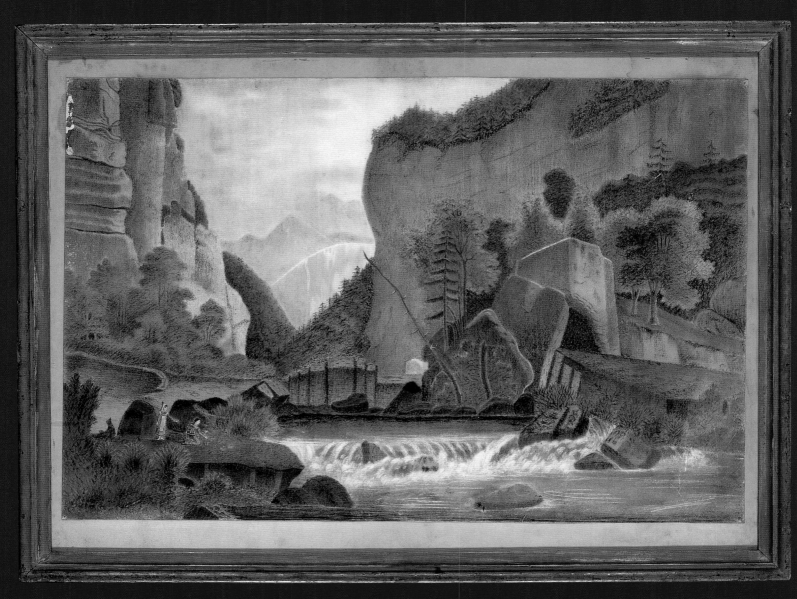

Mountain Landscape
Sarah Marian Southard (or Southworth)
Fairfax, Vermont, 1854
Pastel on wove paper
14⅝ x 21¾ in.
Collection of Abby Aldrich Rockefeller Folk Art Museum,
 Williamsburg, VA
79.202.1

"WANDER HERE A WHOLE SUMMER, IF YOU CAN.

THOUSANDS OF GOD'S WILD BLESSINGS WILL SEARCH

YOU AND SOAK YOU AS IF YOU WERE A SPONGE, AND

THE BIG DAYS WILL GO BY UNCOUNTED."

—JOHN MUIR (1838-1914)

" . . . the idea of a compact AMONG THOSE WHO ARE PARTIES TO A GOVERNMENT IS A FUNDAMENTAL PRINCIPLE OF FREE GOVERNMENT."

—JAMES MADISON (1751-1836)

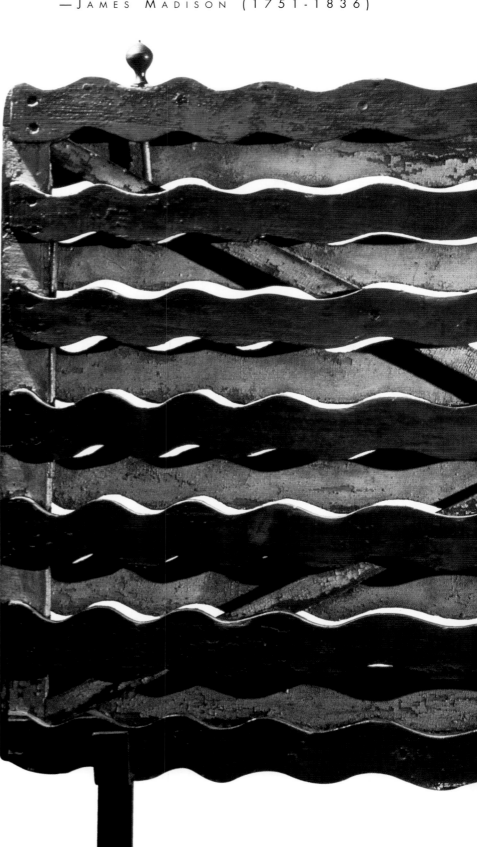

Flag Gate
Artist unidentified
Jefferson County, New York, c. 1876
Paint on wood with iron and brass
39½ x 57 x 3¾ in.
Collection of American Folk Art Museum, New York
Gift of Herbert Waide Hemphill, Jr.
1962.1.1
Photo by John Parnell, New York

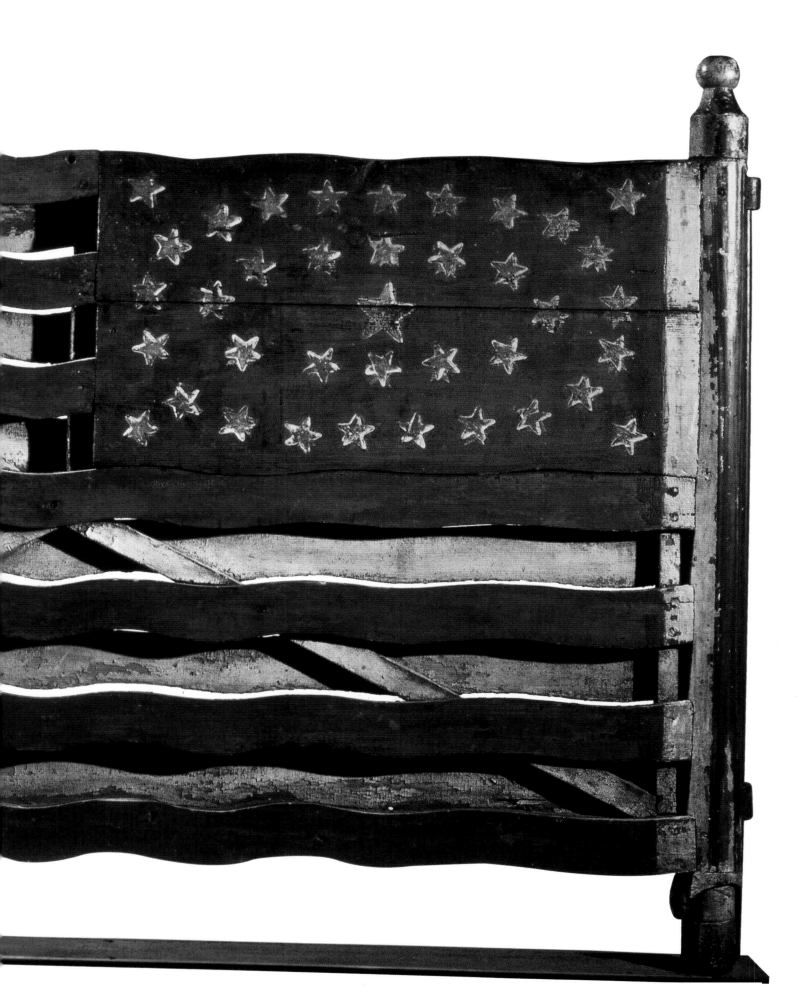

"*So it's home again, and home again,
America for me... My heart is turning home again,
and there I long to be.*"

—HENRY VAN DIKE (1852-1933)

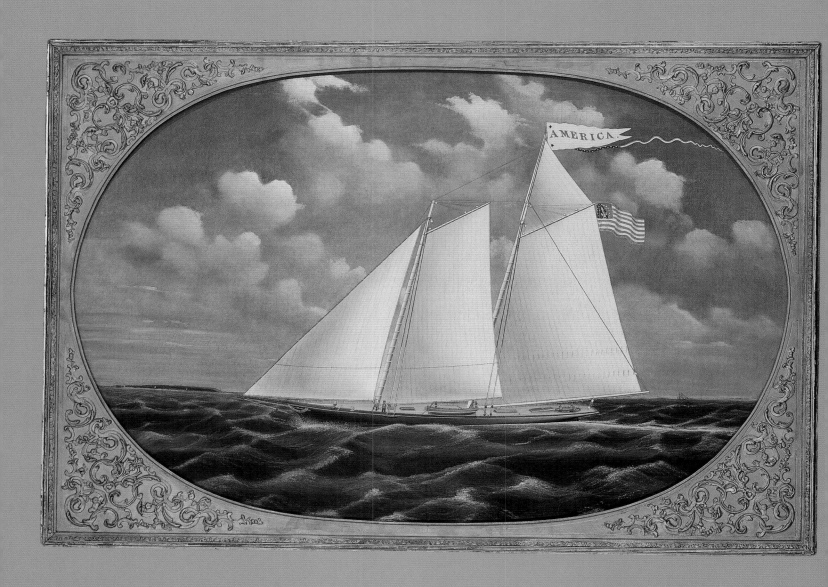

The Schooner Yacht America
James Bard (1815-1897)
New York City, 1851
Oil on canvas with penciled details
41⅞ x 62⅜ in.
Collection of Abby Aldrich Rockefeller Folk Art Museum,
Williamsburg, VA
68.111.1

"America means opportunity, freedom, power."

—RALPH WALDO EMERSON

(1803-1882)

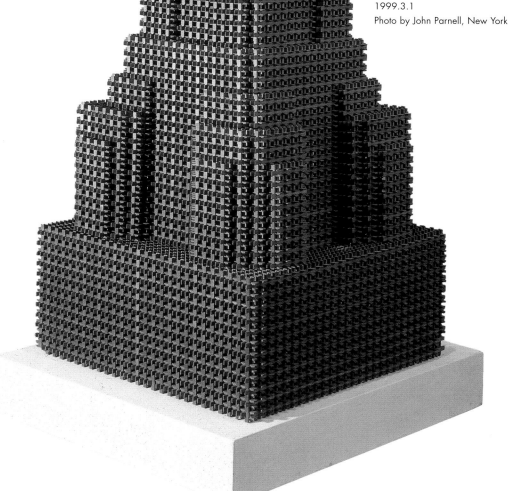

Empire State Building
Artist unidentified
New Jersey, c. 1931
Cherry
94 x 30 x 30 in.
Collection of American Folk Art Museum, New York, NY
Museum purchase made possible through the generosity
 of the Briskin Family Fund in honor of Frank Maresca
1999.3.1
Photo by John Parnell, New York

"Good government is good politics."

—RICHARD J. DALEY, CHICAGO MAYOR (1902-1976)

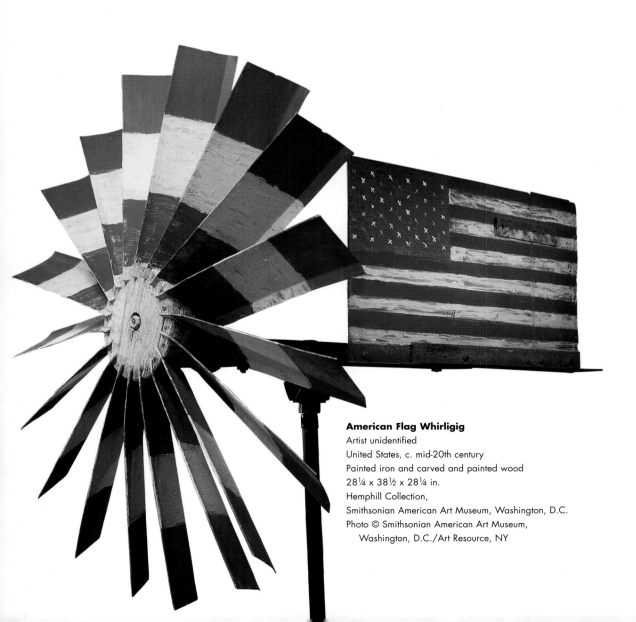

American Flag Whirligig
Artist unidentified
United States, c. mid-20th century
Painted iron and carved and painted wood
28¼ x 38½ x 28¼ in.
Hemphill Collection,
Smithsonian American Art Museum, Washington, D.C.
Photo © Smithsonian American Art Museum,
 Washington, D.C./Art Resource, NY

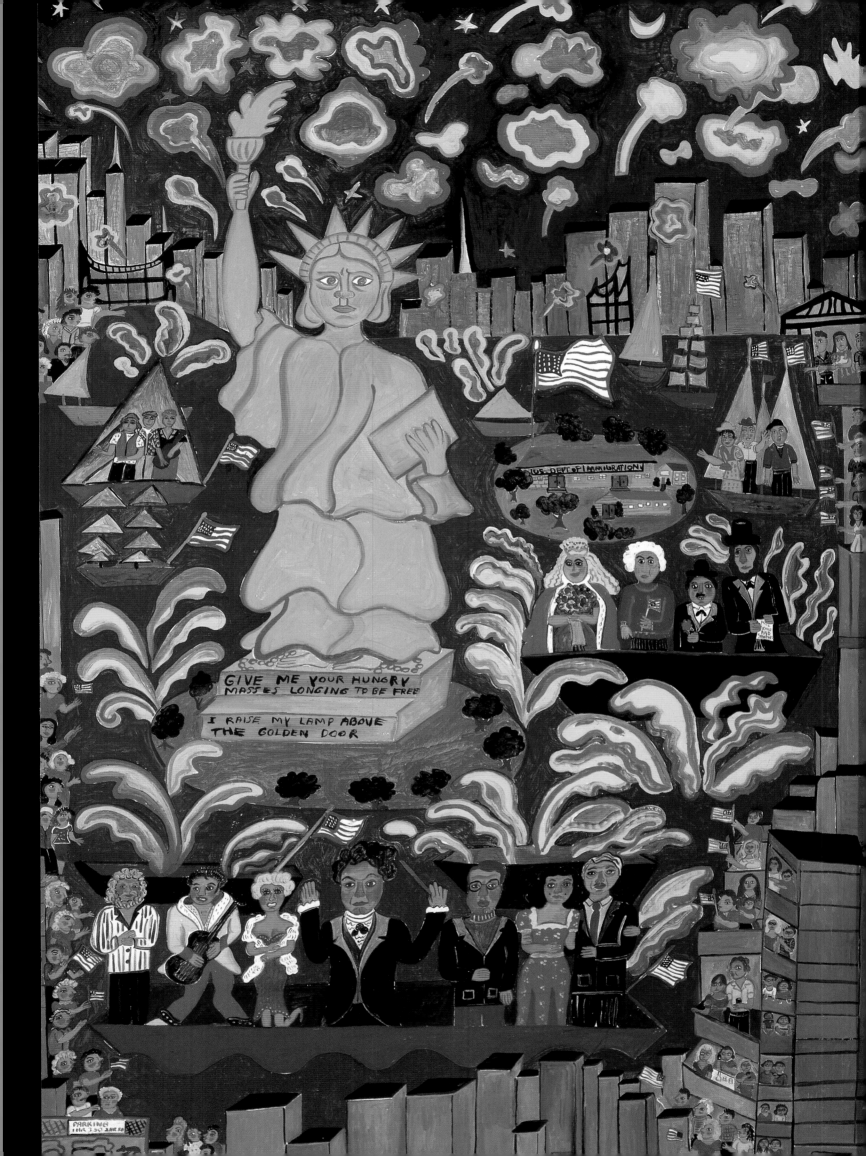

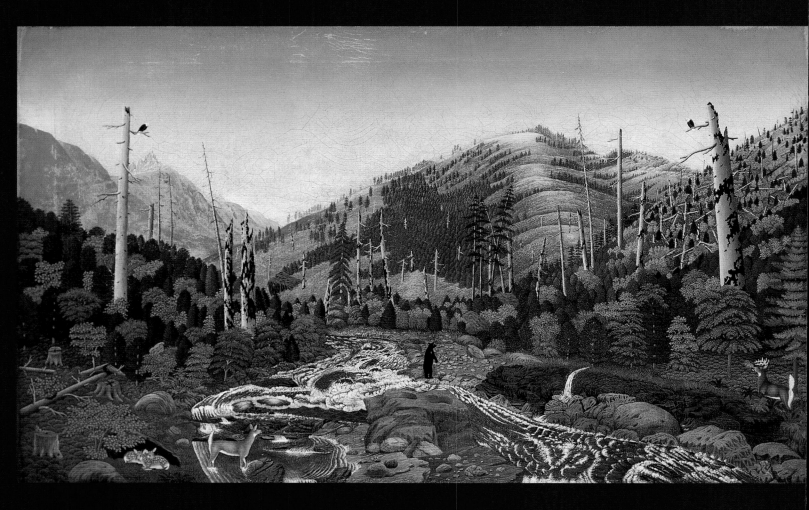

Upper Reaches of Wind River
Steve W. Harley (1863-1947)
Near Carson, Washington, 1927
Oil on canvas
21¼ x 34⅜ in.
Collection of Abby Aldrich Rockefeller Folk Art Museum,
 Williamsburg, VA
57.102.3

"THE WHOLE LANDSCAPE SHOWED DESIGN,

LIKE MAN'S NOBLEST SCULPTURES.

HOW WONDERFUL THE POWER OF ITS BEAUTY! . . .

BEAUTY BEYOND THOUGHT EVERYWHERE,

BENEATH, ABOVE, MADE AND BEING MADE FOREVER."

—JOHN MUIR (1838-1914)

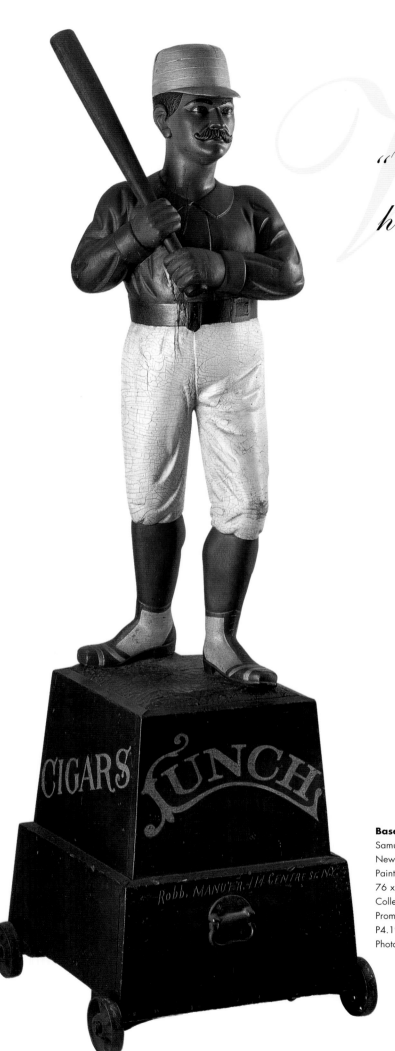

"Whoever wants to know the heart and mind of America had better learn baseball."

—JACQUES BARZUN (B. 1907)

Baseball Player Show Figure
Samuel Anderson Robb (1851-1928)
New York, 1888-1903
Paint on wood
76 x 21¾ x 24 (with wheeled base) in.
Collection of American Folk Art Museum, New York, NY
Promised gift of Millie and Bill Gladstone
P4.1999.1
Photo by Gavin Ashworth, New York

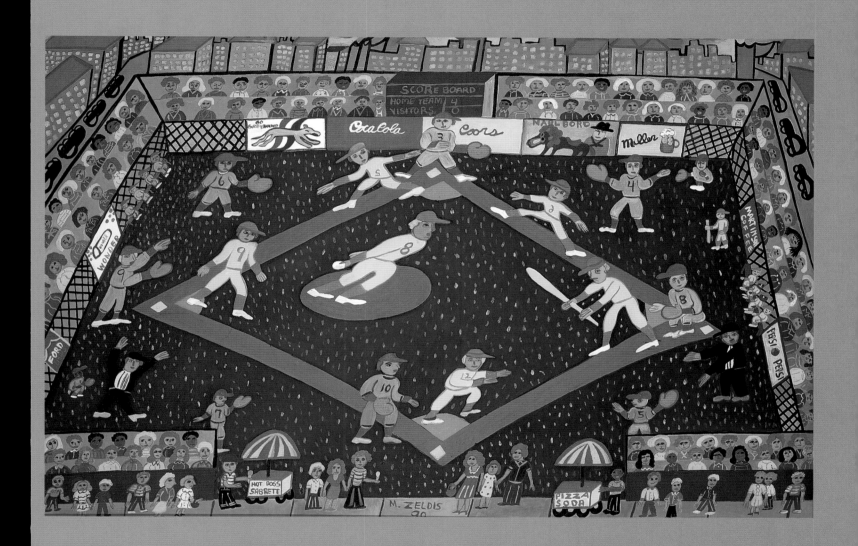

At the Baseball Game
Malcah Zeldis (b. 1931)
New York City
24 x 36 in.
Oil on board
Private collection
Photo © Malcah Zeldis/Art Resource, NY

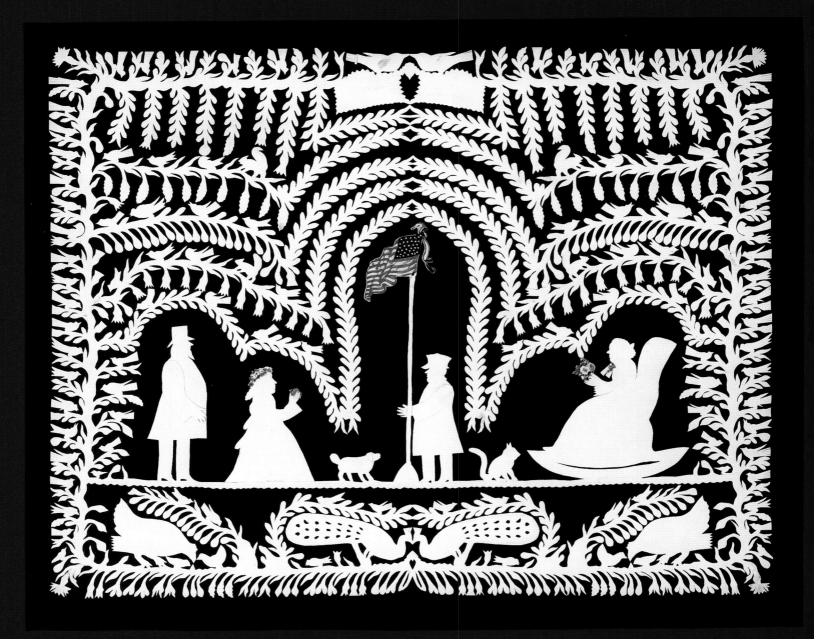

Cutwork Picture
Artist unidentified
Probably Pennsylvania, c. 1860
Wove paper with printed and embossed paper ornaments
15 x 19 in.
Collection of Abby Aldrich Rockefeller Folk Art Museum,
 Williamsburg, VA
63.306.1

S"SOMETIMES PEOPLE CALL ME AN IDEALIST.

WELL, THAT IS THE WAY I KNOW I AM AN AMERICAN.

AMERICA IS THE ONLY IDEALISTIC NATION IN THE WORLD."

—WOODROW WILSON (1856-1924)

"Don't sell America short."

—SAYING, C. 1925

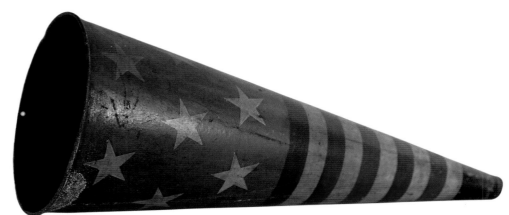

Flag Megaphone
Artist unidentified
United States; early 20th century
Paint on metal
30 x 15 in.
Collection of the American Folk Art Museum,
New York, NY
Gift of Bruce Laconte
1983.2.1

*"Politics is largely
a matter of heart."*

— R.A. BUTLER (1902–1982)

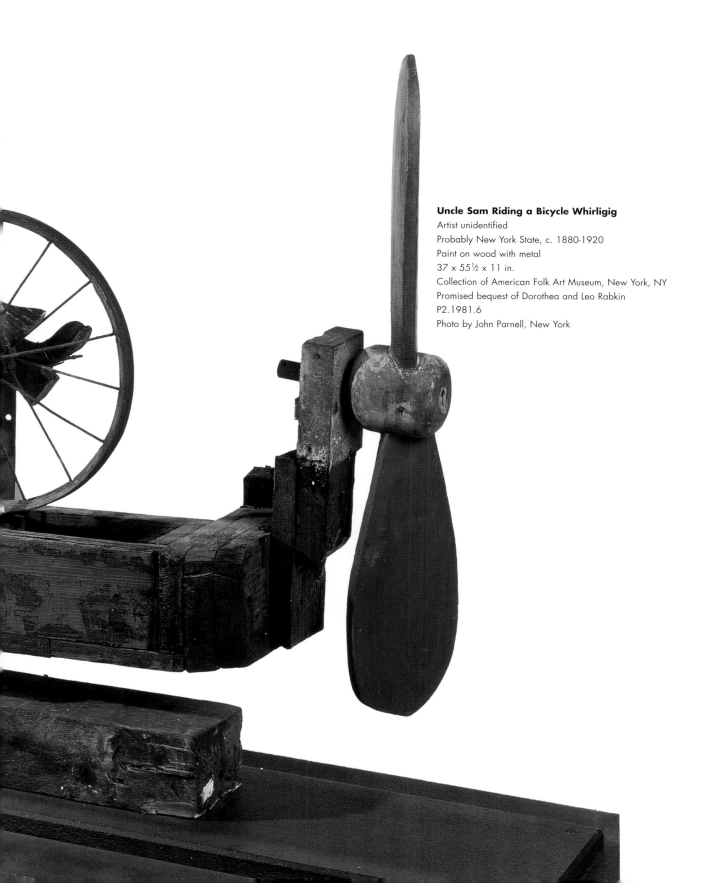

Uncle Sam Riding a Bicycle Whirligig
Artist unidentified
Probably New York State, c. 1880-1920
Paint on wood with metal
37 x 55½ x 11 in.
Collection of American Folk Art Museum, New York, NY
Promised bequest of Dorothea and Leo Rabkin
P2.1981.6
Photo by John Parnell, New York

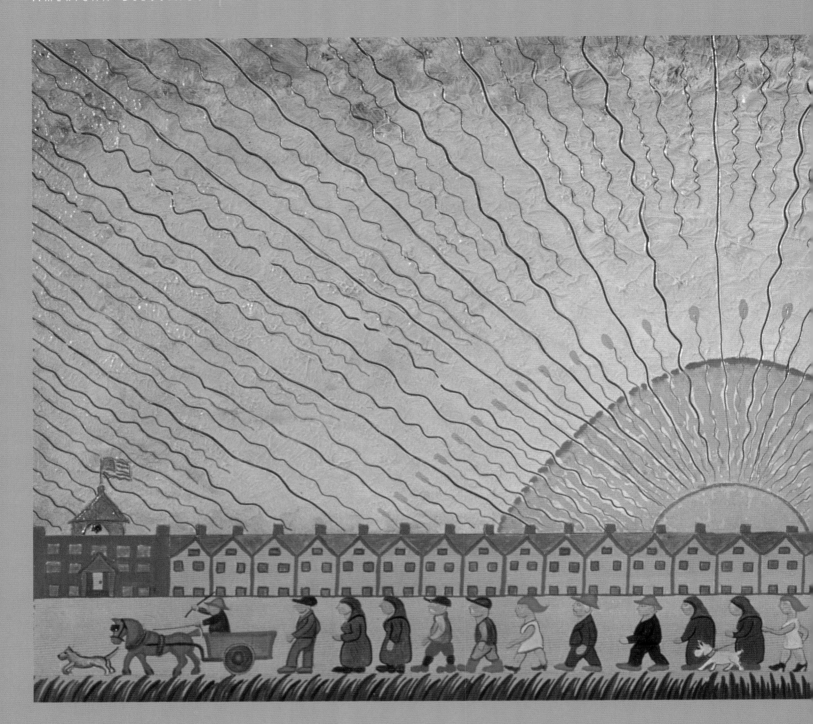

Sunrise
John "Jack" Savitsky (1910-1991)
Lansford, Carbon Country, Pennsylvania, 1964
Oil on masonite
24 x 48 in.
Collection of American Folk Art Museum, New York, NY
Promised gift of David L. Davies
P4.1998.26
Photo by John Parnell, New York

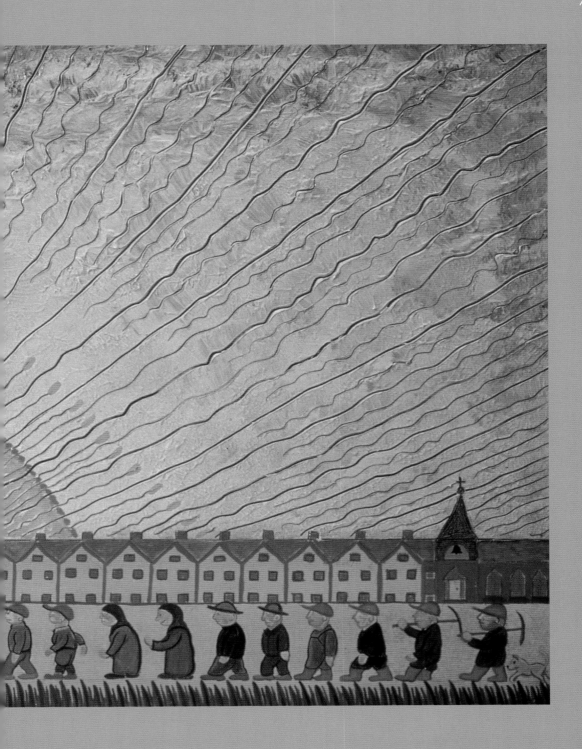

"THE SACRED RIGHTS OF MANKIND . . . ARE WRITTEN, AS WITH A SUN-

BEAM, IN THE WHOLE VOLUME OF HUMAN NATURE BY THE HAND OF

THE DIVINITY ITSELF."

—ALEXANDER HAMILTON (1755–1804)

Josiah Turner Boot Sign
Artist unidentified
Probably Massachusetts, c. 1810
Oil on white pine
18¾ x 44 x 1¾ in.
Collection of Abby Aldrich Rockefeller Folk Art Museum,
 Williamsburg, VA
58.707.1

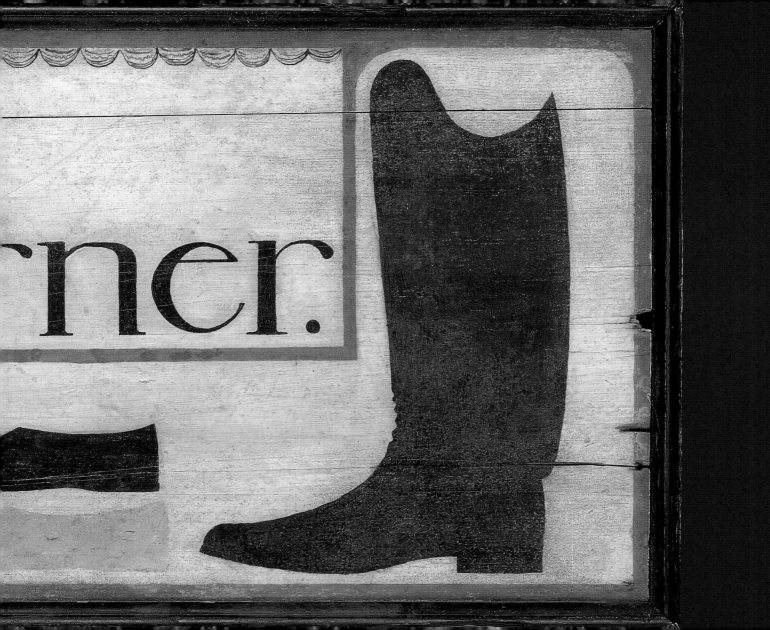

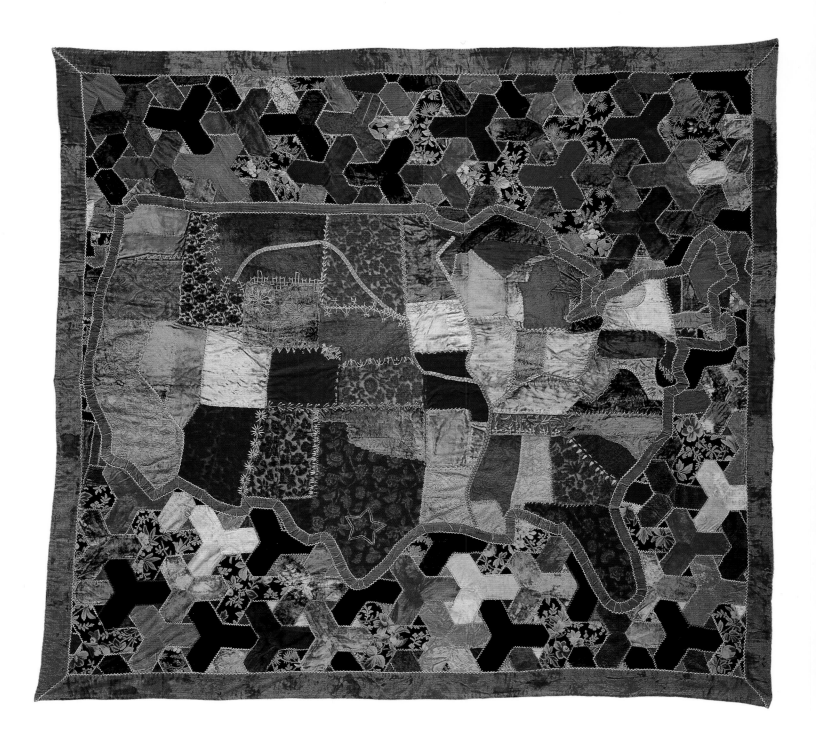

"America is not a blanket WOVEN FROM ONE THREAD,

ONE COLOR, ONE CLOTH."

—JESSE JACKSON (B. 1941)

Map Quilt
Artist unidentified
Possibly Virginia, 1886
Silk and cotton with silk embroidery and cotton sateen backing
78¾ x 82¼ in.
Collection of American Folk Art Museum, New York, NY
Gift of Dr. and Mrs. C. David McLaughlin
1987.1.1
Photo by Schecter Lee, New York

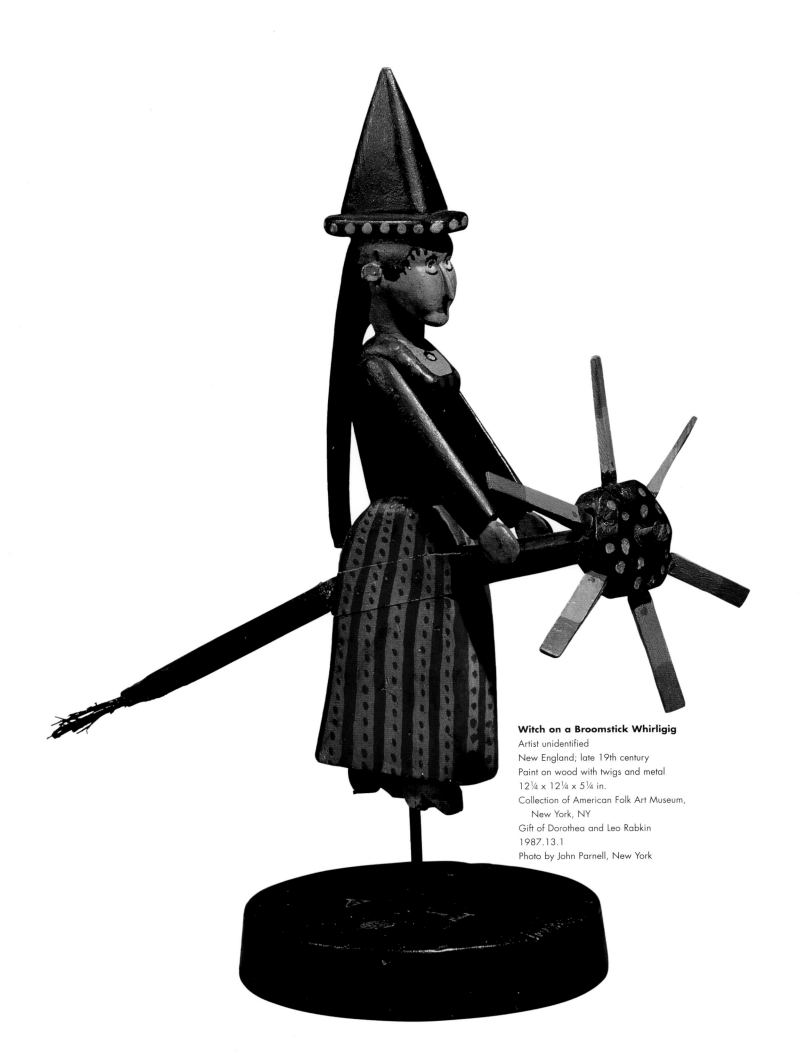

Witch on a Broomstick Whirligig
Artist unidentified
New England; late 19th century
Paint on wood with twigs and metal
12¼ x 12¼ x 5¼ in.
Collection of American Folk Art Museum,
 New York, NY
Gift of Dorothea and Leo Rabkin
1987.13.1
Photo by John Parnell, New York

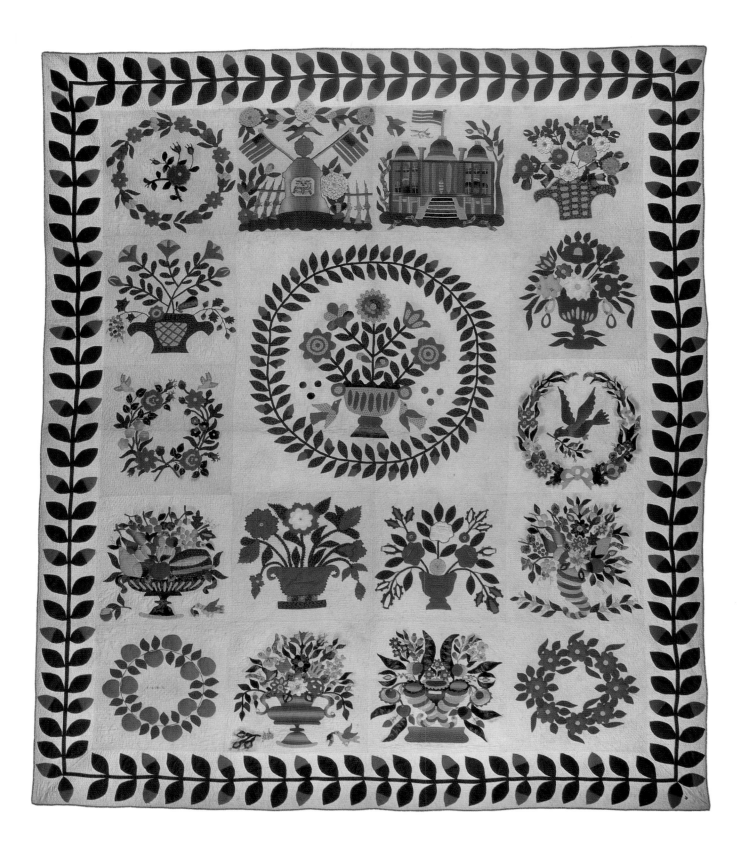

Appliquéd Quilt
Sarah Anne Whittington Lankford (1830-1898), probably Mary Evans, and possibly others
Baltimore and Somerset County, Maryland, ca. 1850
Various cottons with inked details and silver metallic thread
84 x 99 in.
Collection of Abby Aldrich Rockefeller Folk Art Museum, Williamsburg, VA
Gift of Marsha C. Scott
79.609.14

I "I PLAN TO STAND UP AND BE COUNTED. AND THE THING

I'M GONNA DO IS, I'M GONNA DO WHAT WE'RE

GONNA DO RIGHT NOW. I'M GOING TO THE PEOPLE AND SAY,

'NOW THIS IS WHAT I'M TRYING TO DO.'

AND I'M GOING TO DO THIS BECAUSE

I BELIEVE THE PEOPLE NEED REPRESENTATION."

—PAUL EGGERS, TEXAS

GUBERNATORIAL CANDIDATE (R)

"O beautiful for spacious skies,

For amber waves of grain,

For purple mountain majesties

Above the fruited plain!

America! America!

God shed his grace on thee

And crown thy good with brotherhood

From sea to shining sea!"

—Katharine Lee Bates (1859-1929)

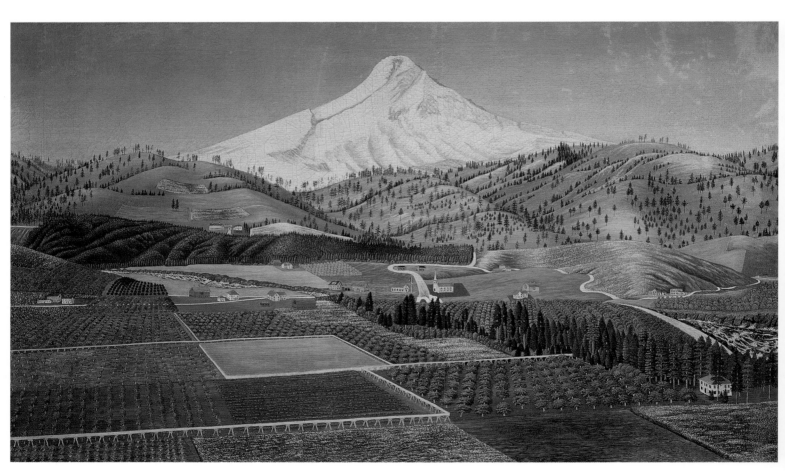

South End of Hood River Valley
Steve W. Harley (1863-1947)
Near Mount Hood, Washington, 1927
Oil on canvas
20 x 33⅜ in.
Collection of Abby Aldrich Rockefeller Folk Art Museum,
 Williamsburg, VA
57.102.2